HIROSHIGE

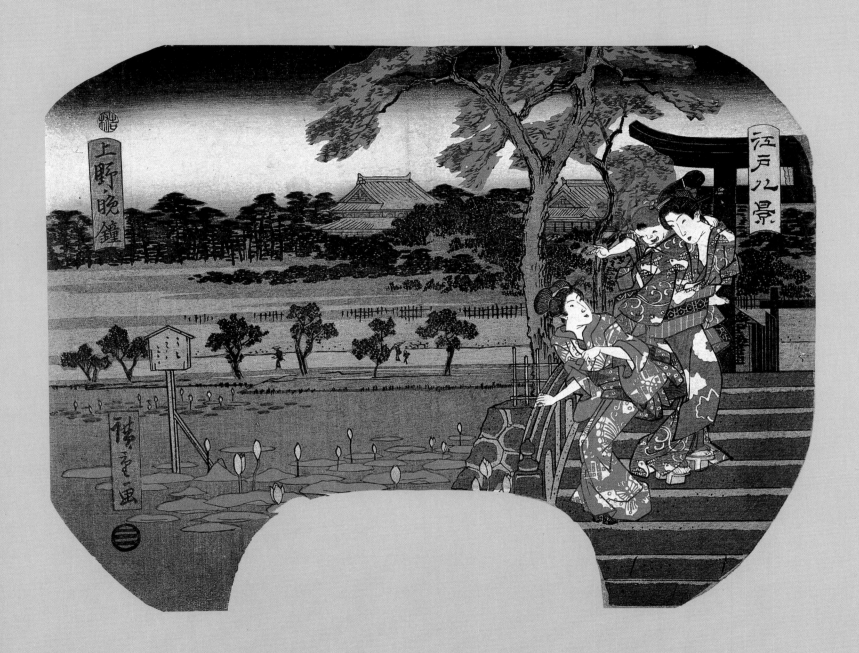

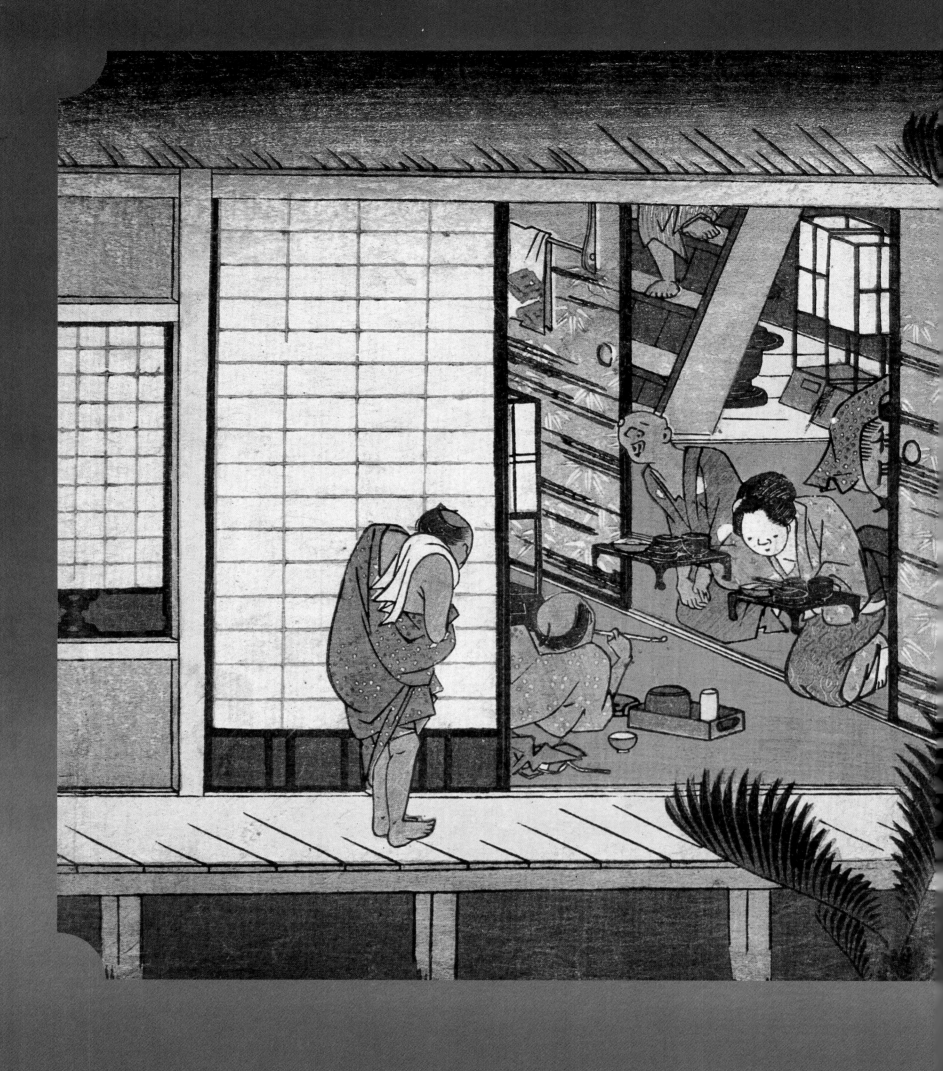

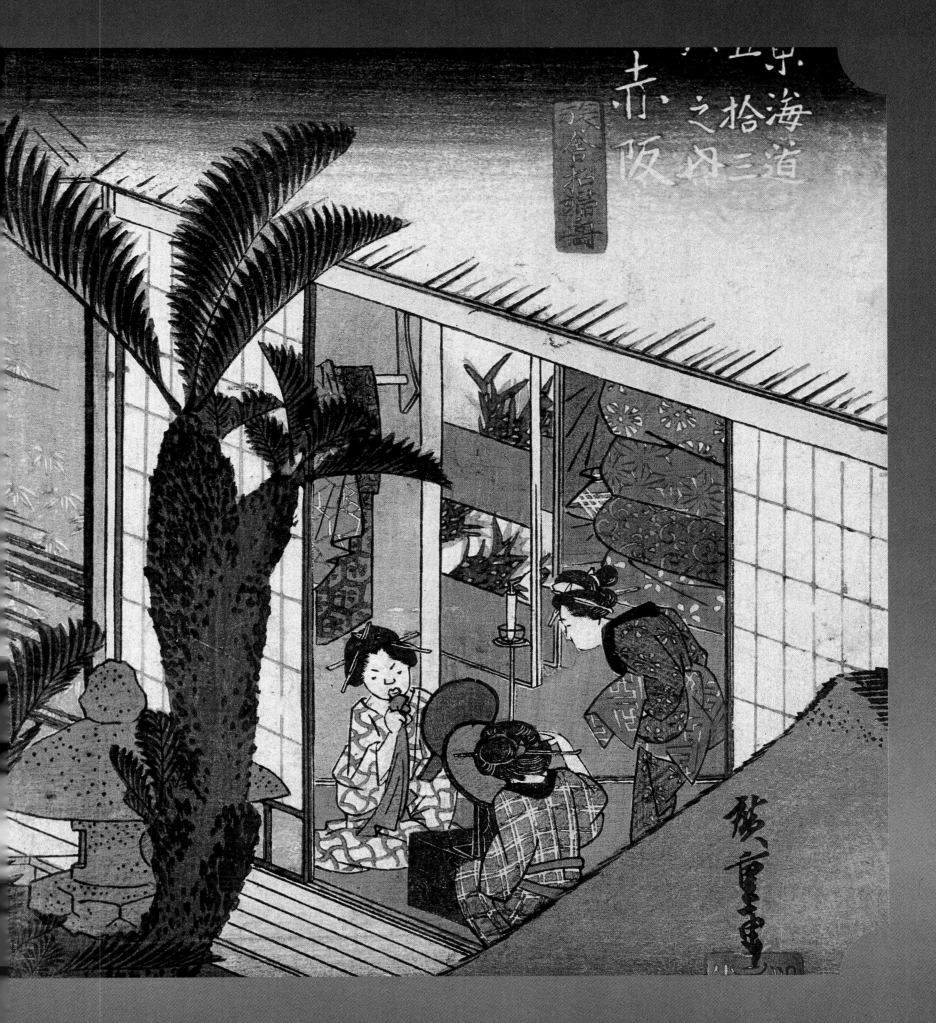

HIROSHIGE

Isaburō Oka
Translated by Stanleigh H. Jones

ROBERT G SAWERS PUBLISHING
With the cooperation of
KODANSHA INTERNATIONAL LTD.

Goyu: "Fifty-three Stages of the Tōkaidō."

Half-title page. *Evening Bells at Ueno:* "Eight Views of Ueno."
Title pages. *Akasaka:* "Fifty-three Stages of the Tōkaidō."

Note to the Reader: Japanese names are given in the customary
Japanese order, surname preceding given name.

Published with the cooperation of Kodansha International Ltd. and
distributed in Great Britain and Europe by Robert G Sawers Pub-
lishing, PO Box 4QA, London W1A 4QA, England.

Originally published and distributed throughout the rest of the
world by Kodansha International Ltd., 12-21, Otowa 2-chome,
Bunkyo-ku, Tokyo 112, Japan and Kodansha International/USA
Ltd., 10 East 53rd Street, New York 10022 and 44 Montgomery
Street, San Francisco, California 94104.

ISBN 0-903697-18-1 (Robert G Sawers Publishing)

Contents

The Man and His Work 33

An Unhappy Childhood 33

The Young Artist 34

The Mature Hiroshige 36

Composition and Technique 41

 Notes on the Color Plates 42

 Standard Print Sizes 42

 Bibliography 45

 "Fifty-three Stages of the Tōkaidō" 46

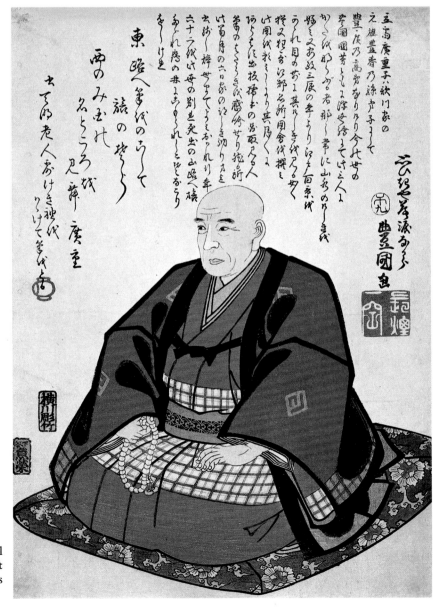

Posthumous portrait of Hiroshige by Toyokuni III. Hiroshige's farewell poem on the print reads: "Upon the eastern road/My brush I've left behind./Now on a journey through the skies,/I go to see the famous places/In the Western Paradise."

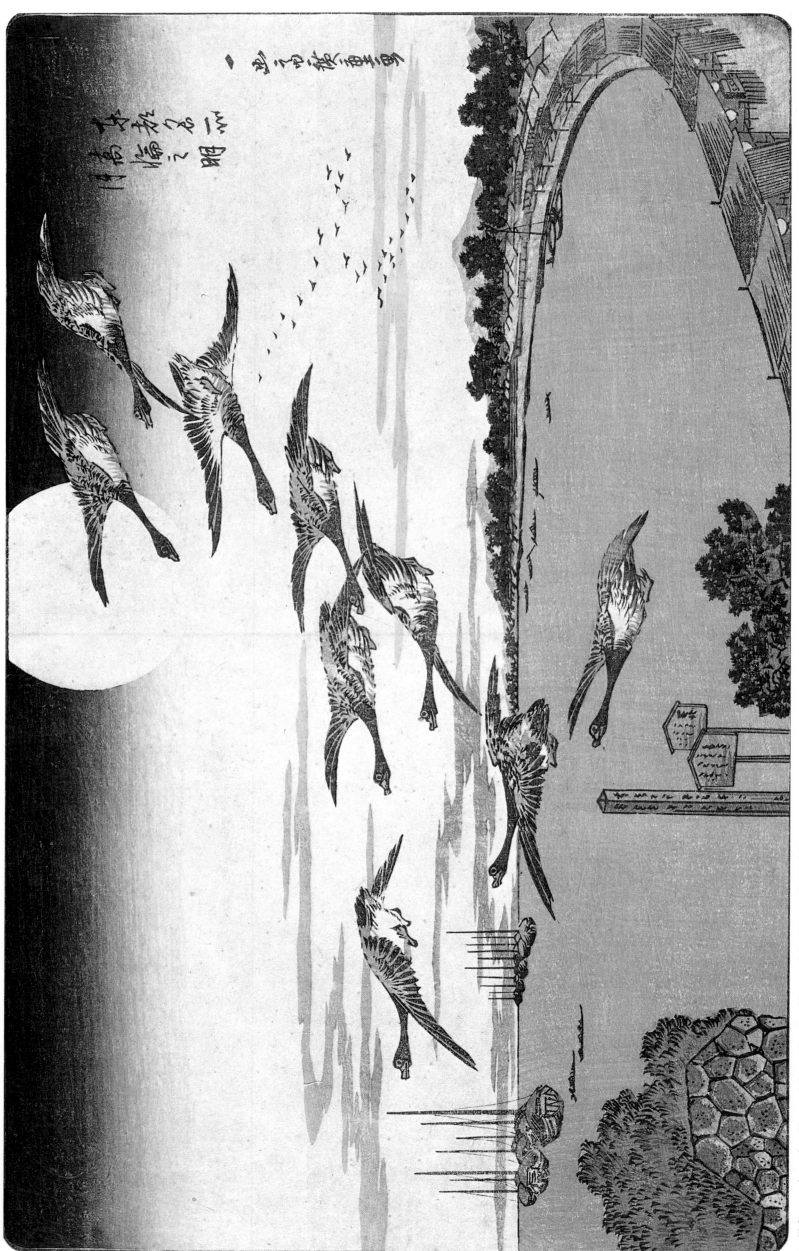

1. *Takanawa beneath a Harvest Moon:* "Famous Places of the Eastern Capital."

2. *Ryōgoku under an Evening Moon:* "Famous Places of the Eastern Capital."

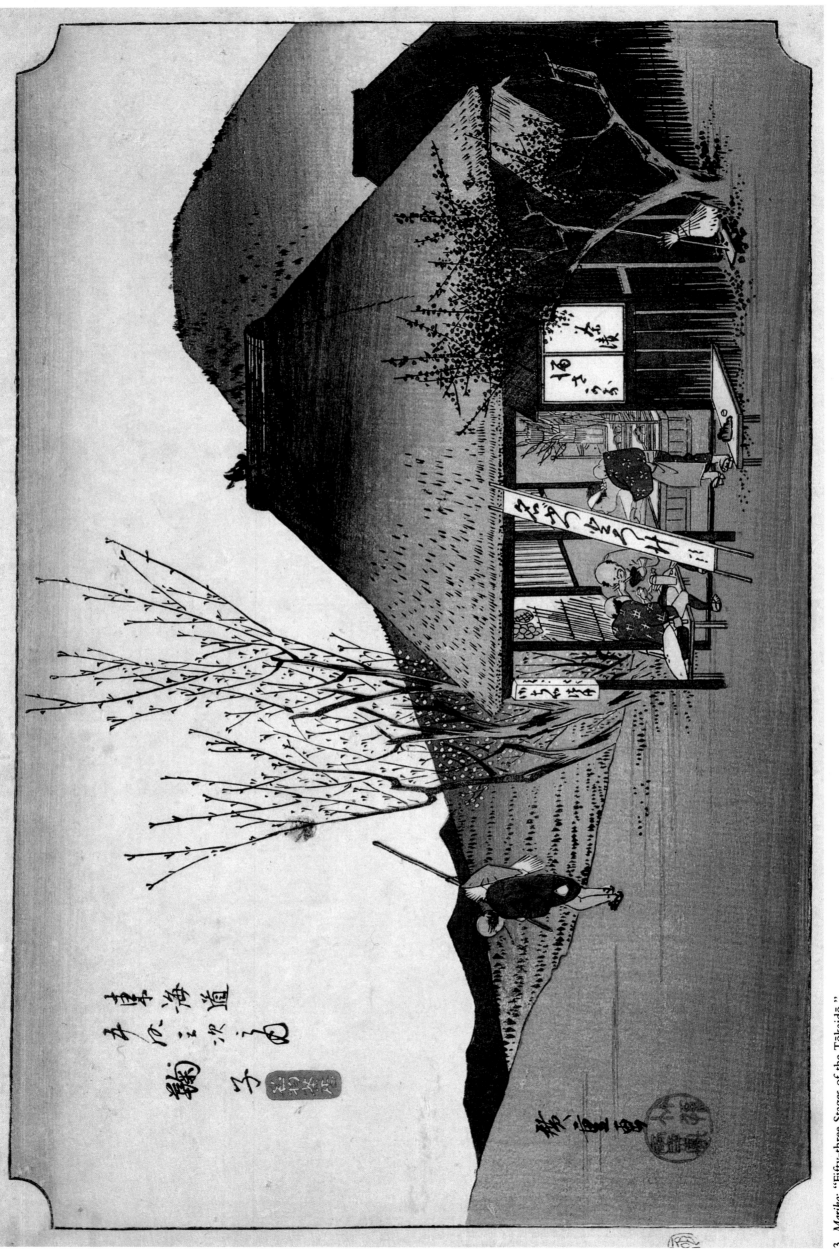

3. *Mariko:* "Fifty-three Stages of the Tōkaidō."

4. *Numazu*: "Fifty-three Stages of the Tōkaidō."

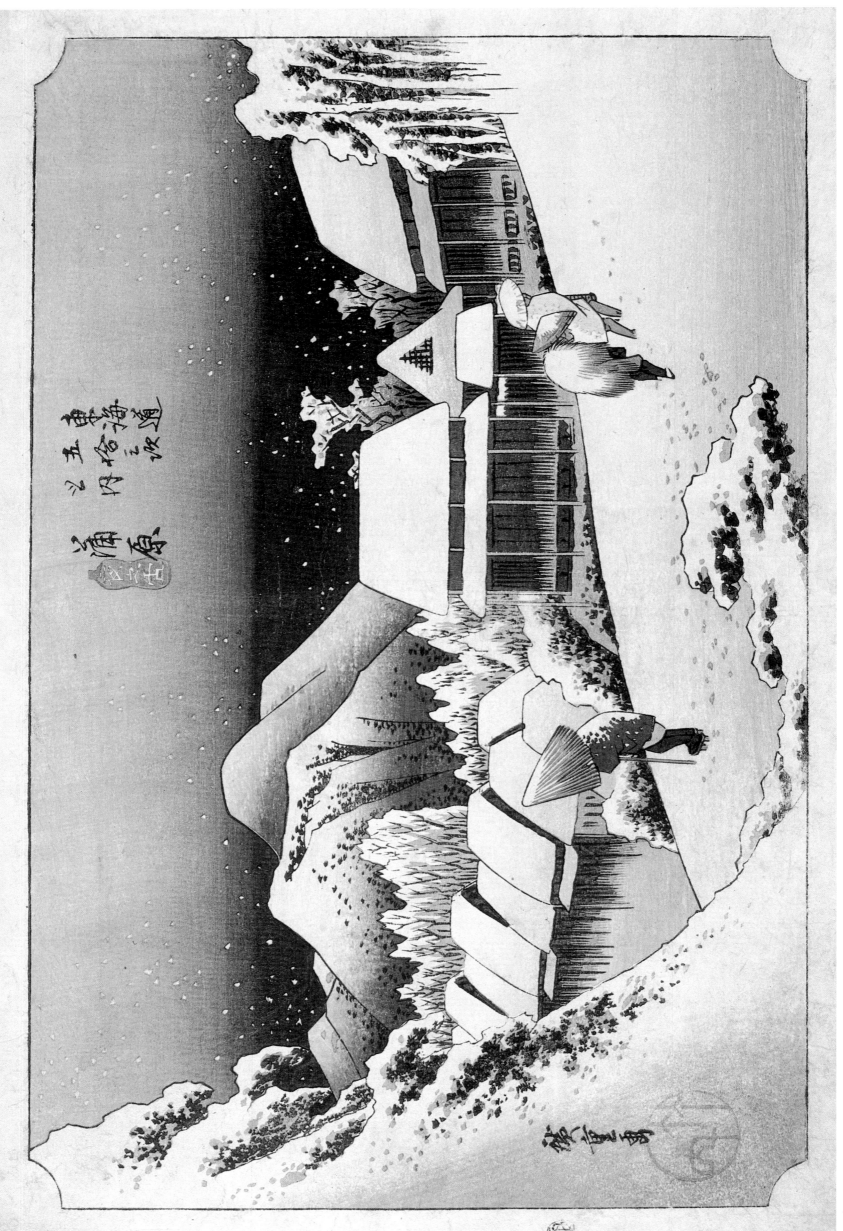

5. *Kanbara:* "Fifty-three Stages of the Tōkaidō."

6. *Shōno:* "Fifty-three Stages of the Tōkaidō."

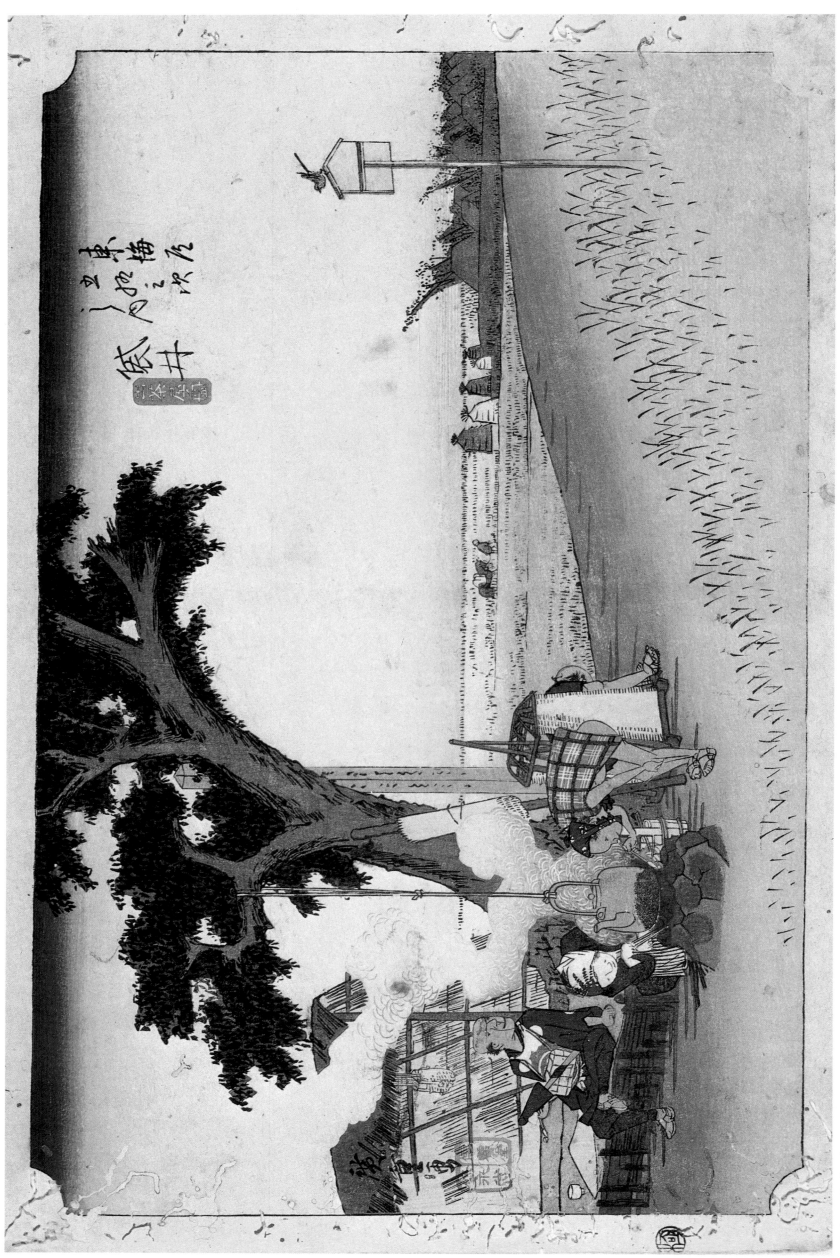

7. *Fukuroi:* "Fifty-three Stages of the Tōkaidō."

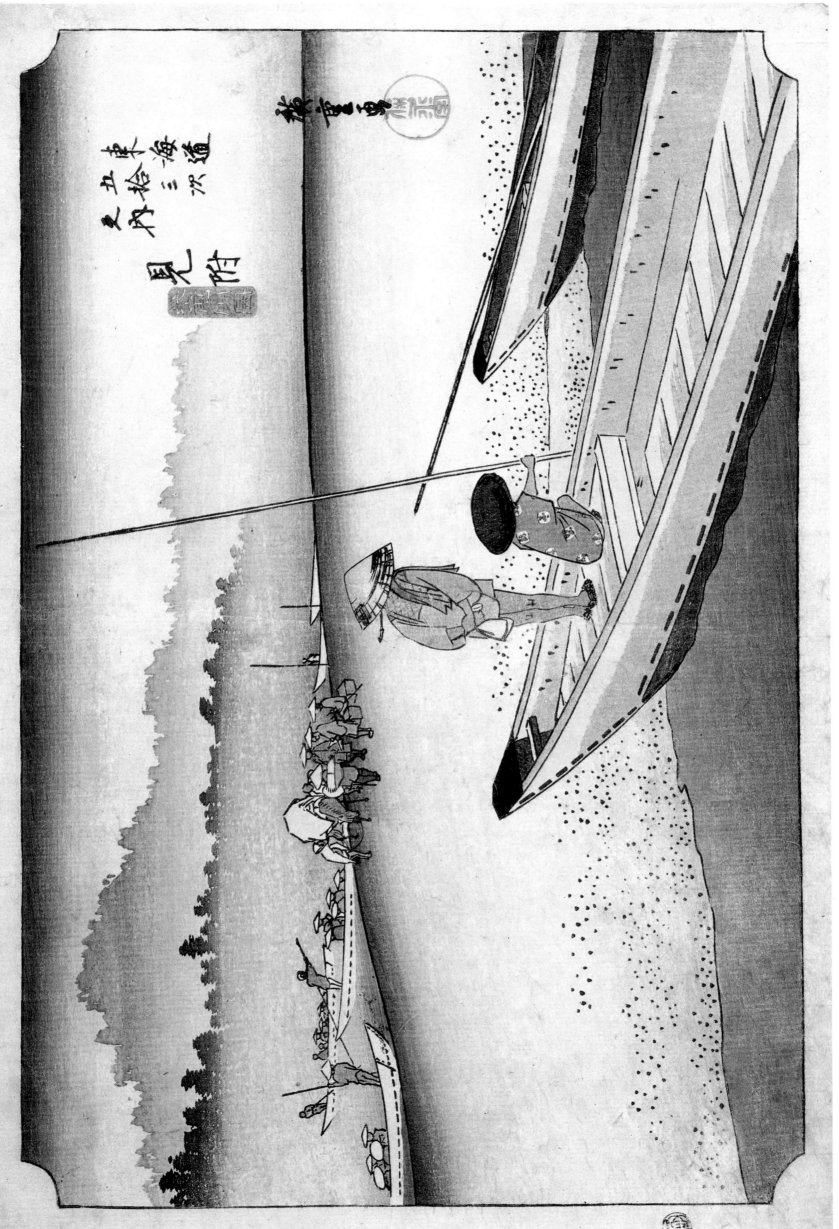

8. *Mitsuke*: "Fifty-three Stages of the Tōkaidō."

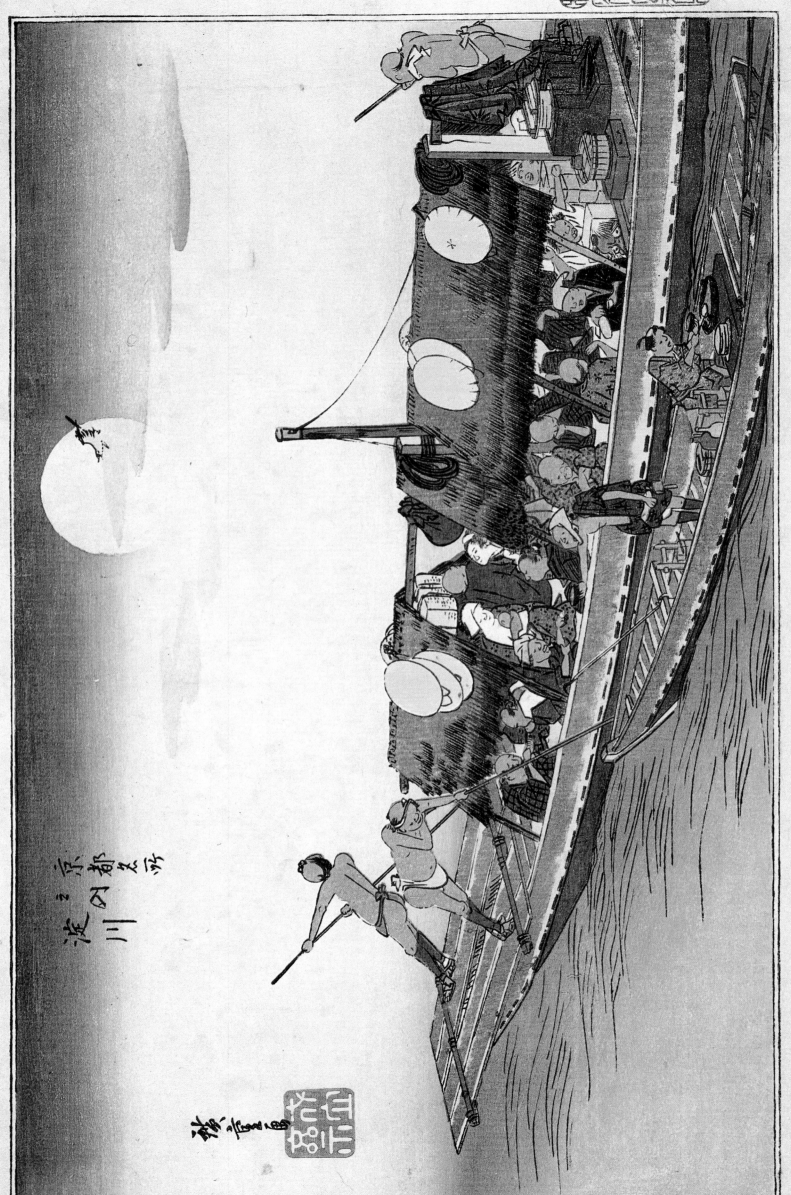

9. *Yodo River.* "Famous Places of Kyoto."

10. *Cherries in Full Bloom at Arashiyama:* "Famous Places of Kyoto."

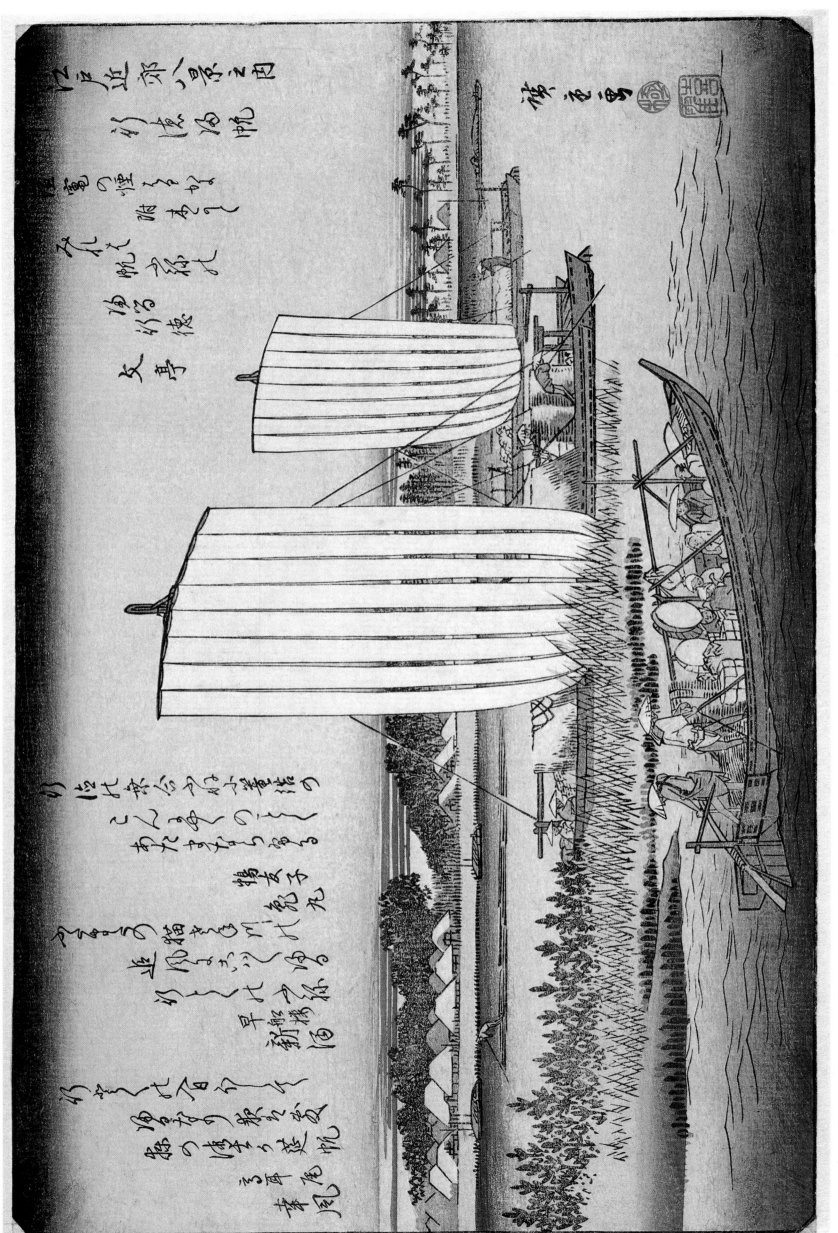

11. *Returning Sails at Gyōtoku:* "Eight Views of the Edo Environs."

12. *Autumn Moon over Tamagawa:* "*Eight Views of the Edo Environs.*"

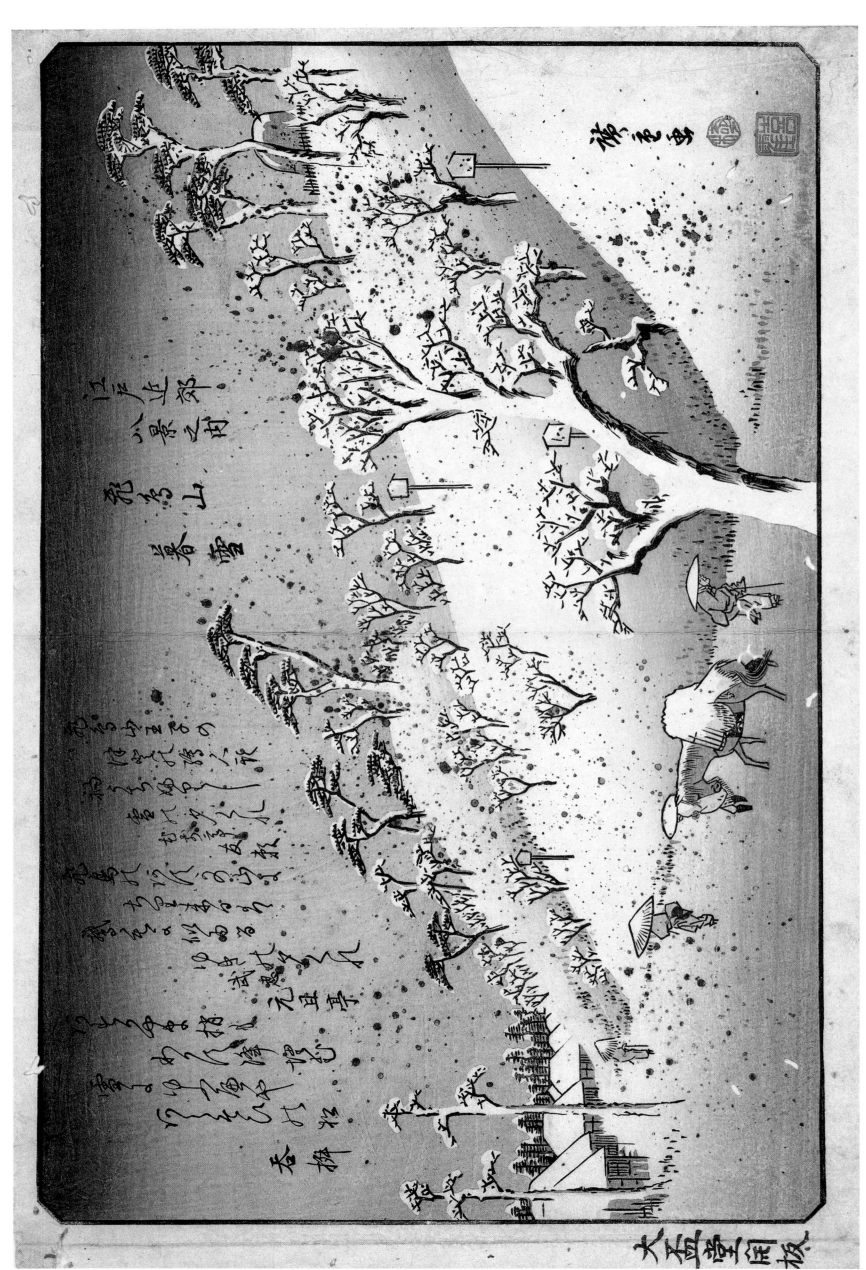

13. *Evening Snow at Asukayama:* "Eight Views of the Edo Environs."

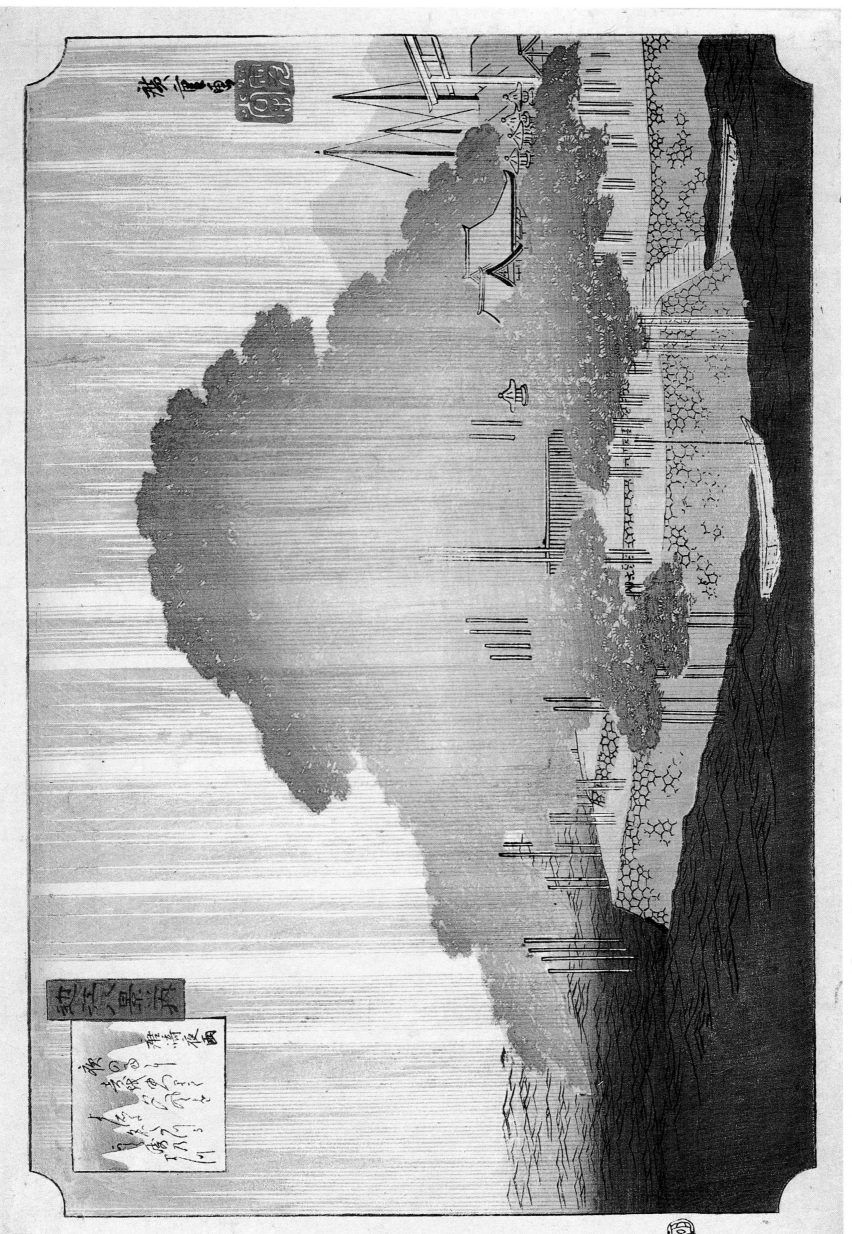

14. *Night Rain at Karasaki:* "Eight Famous Views of Ōmi Province."

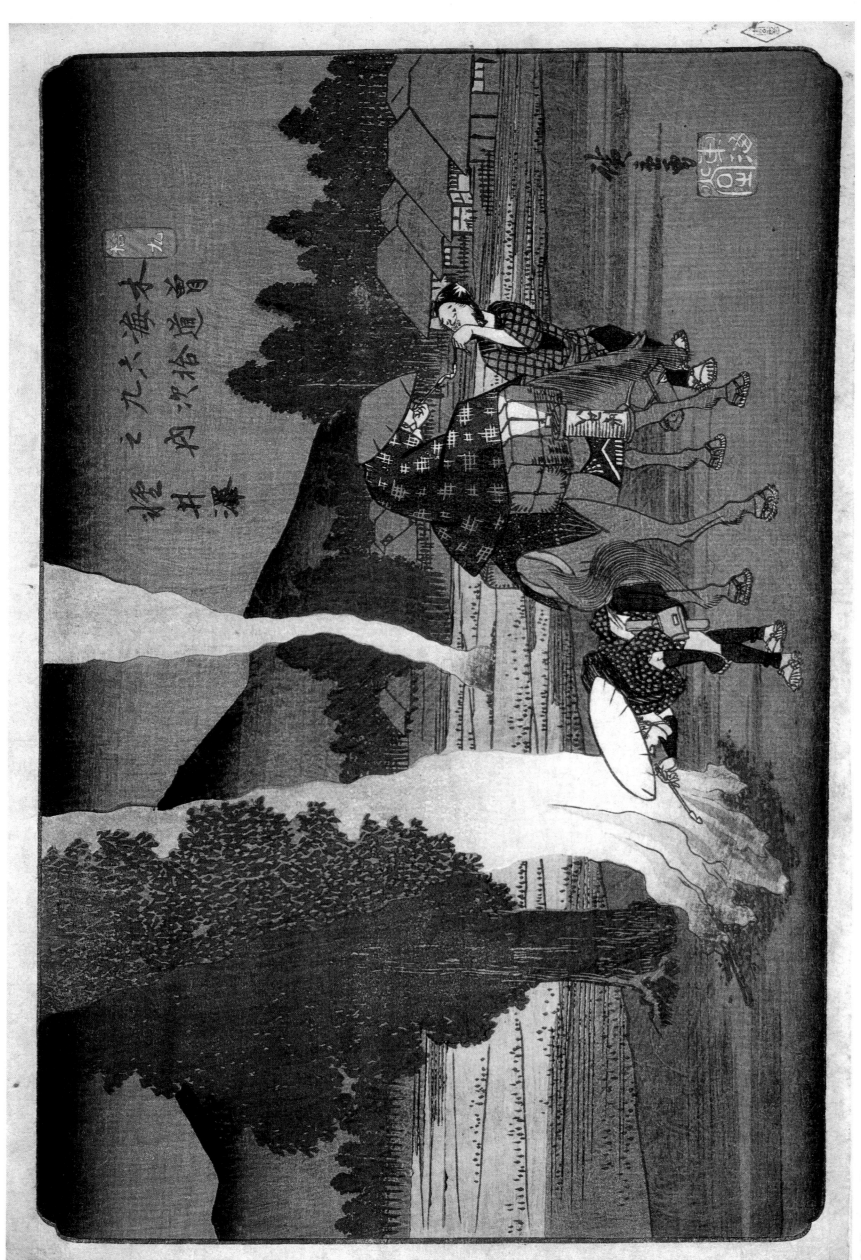

15. *Karuizawa:* "Sixty-nine Stages of the Kisokaidō."

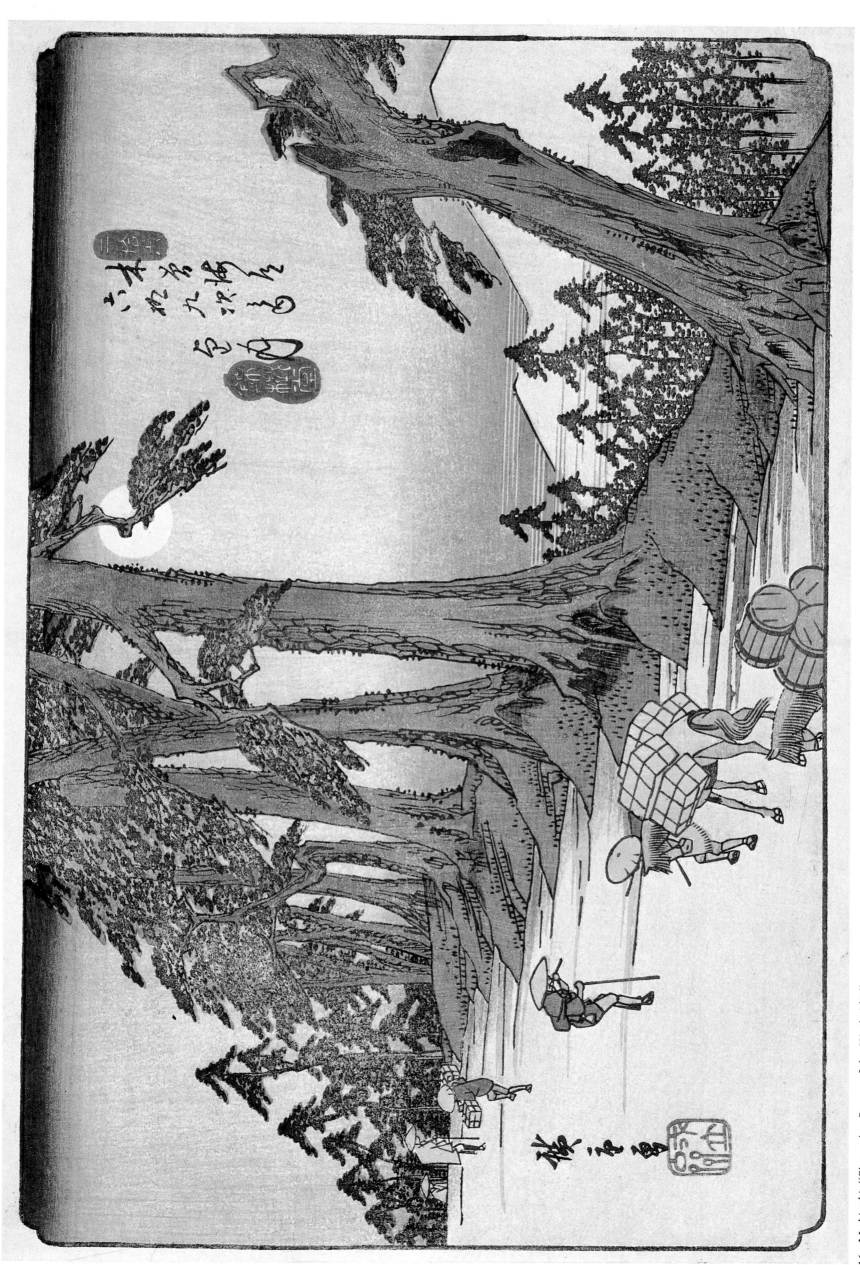

16. *Mochizuki:* "Sixty-nine Stages of the Kisokaidō."

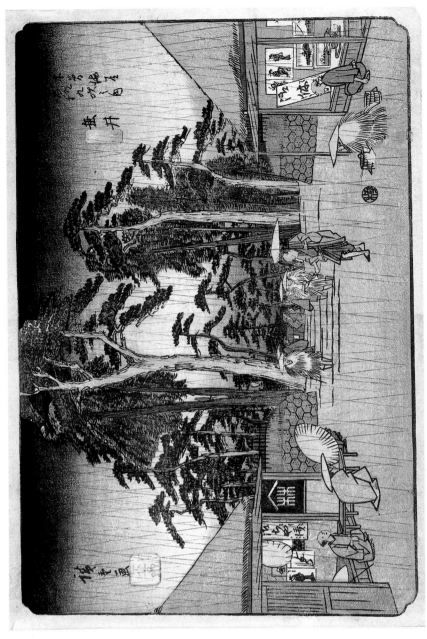

18. *Tarui:* "Sixty-nine Stages of the Kisokaidō."

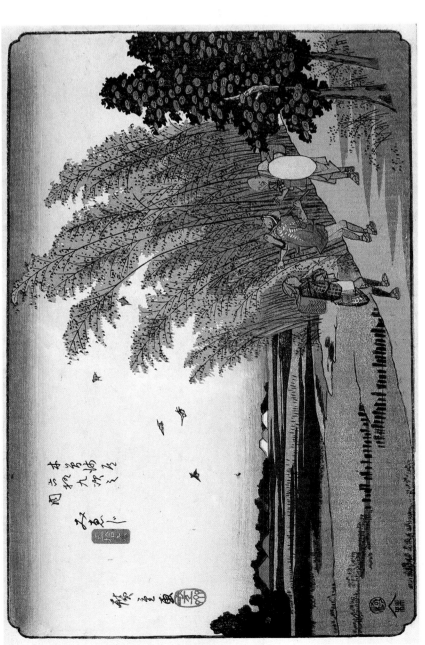

17. *Mieji:* "Sixty-nine Stages of the Kisokaidō."

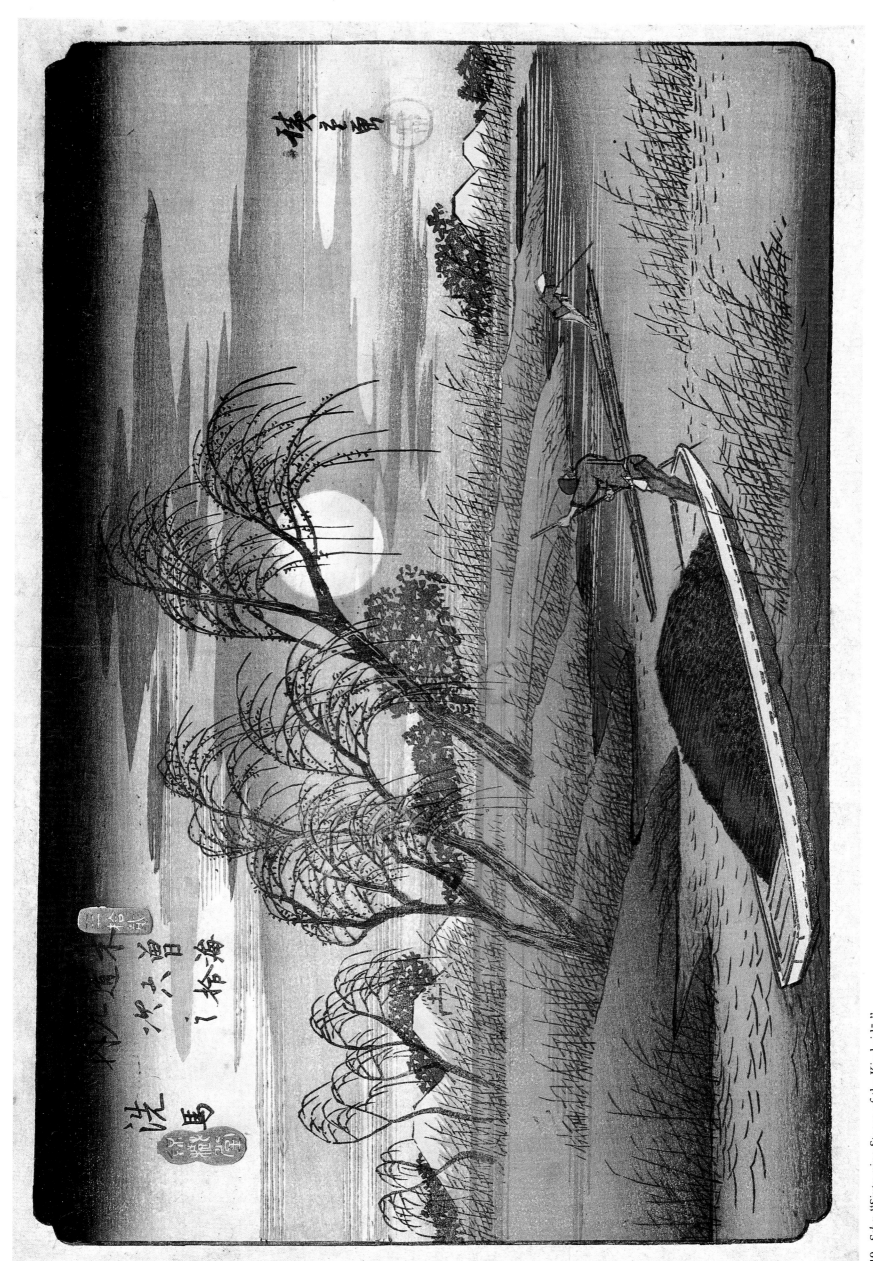

19. *Seba:* "Sixty-nine Stages of the Kisokaidō."

21. *Crowds in the Theater Quarter:* "Famous Places of the Eastern Capital."

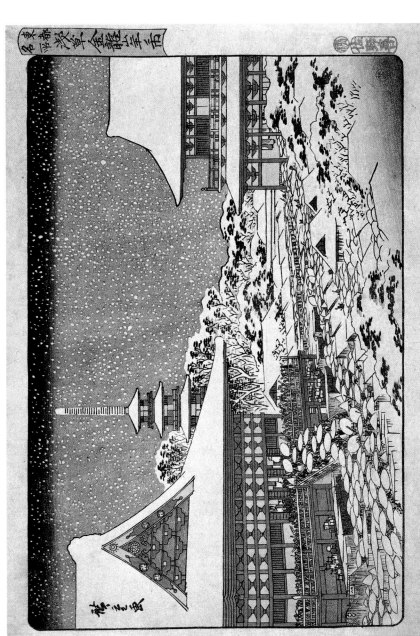

20. *New Year's Market at Asakusa Temple:* "Famous Places of the Eastern Capital."

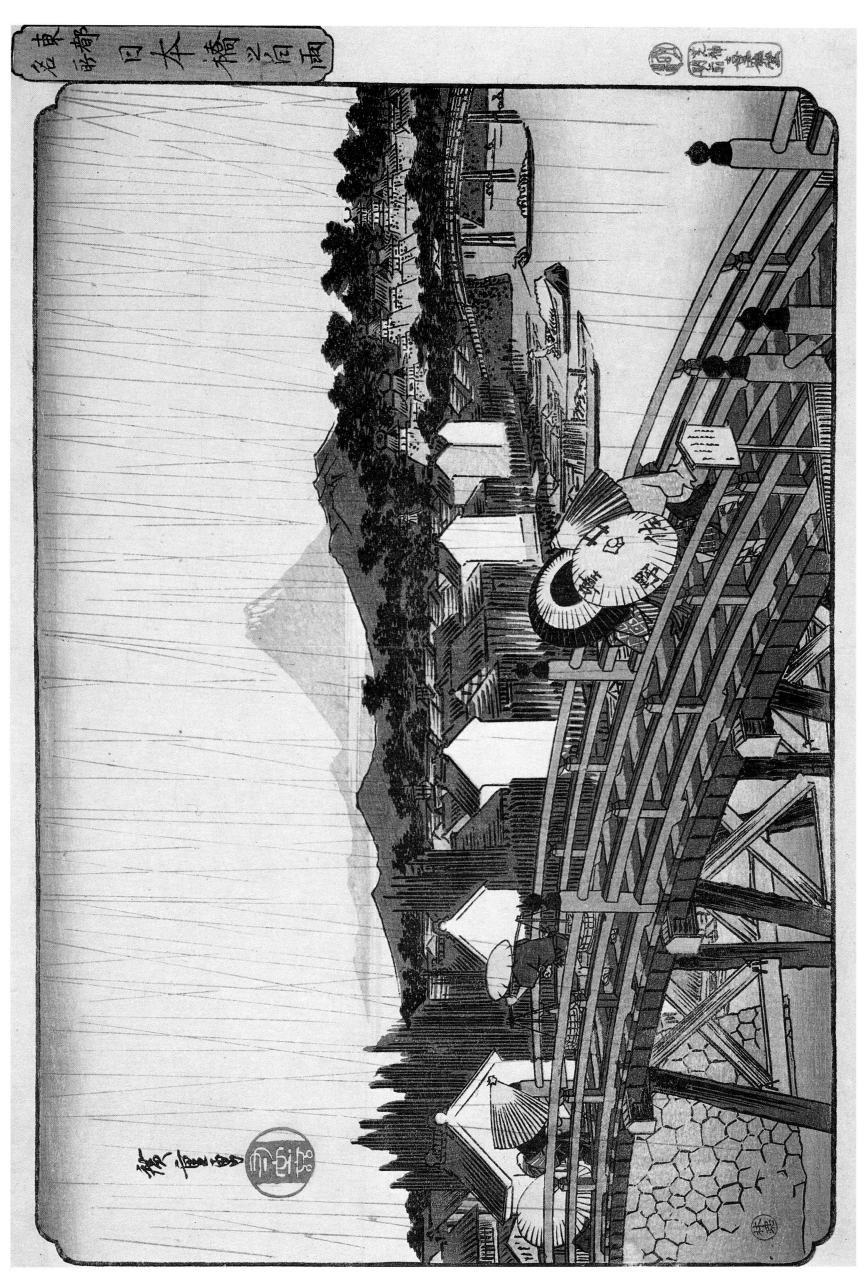

22. *Shower on Nihonbashi*: "Famous Places of the Eastern Capital."

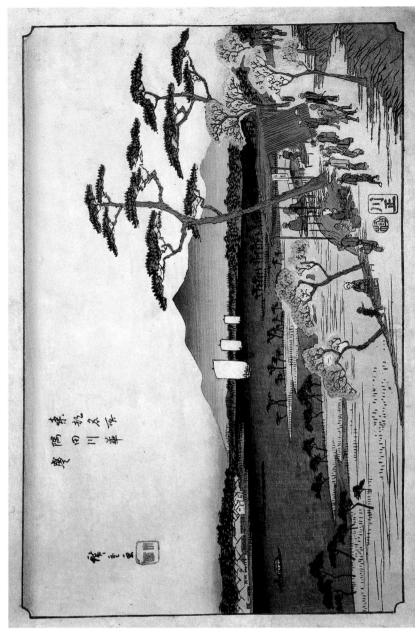

24. *Cherry Blossoms at Their Peak along Sumida River:* "*Famous Places of the Eastern Capital.*"

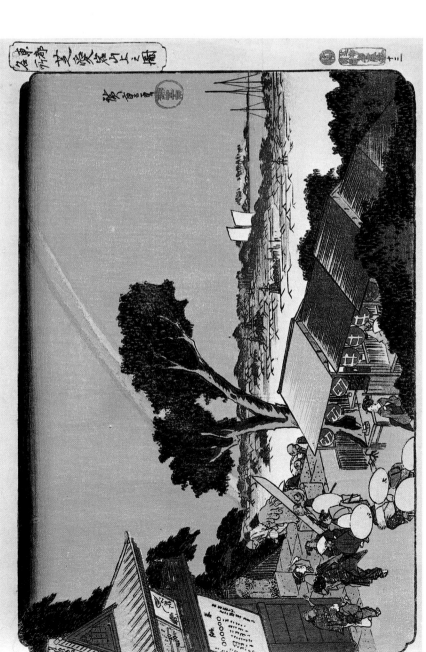

23. *Atop Mount Atago in the Shiba District:* "*Famous Places of the Eastern Capital.*"

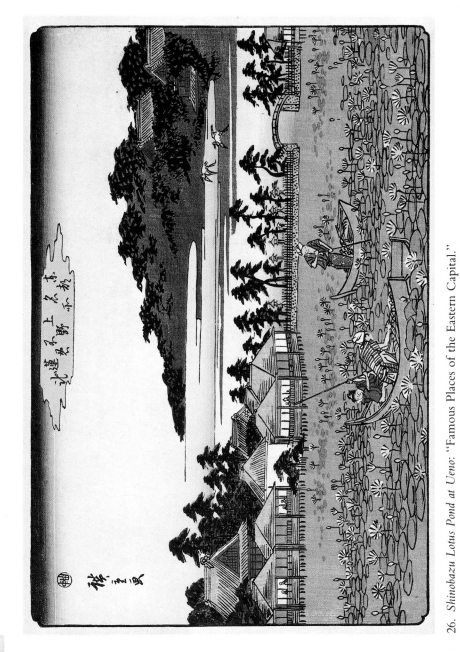

26. *Shinobazu Lotus Pond at Ueno:* "Famous Places of the Eastern Capital."

25. *Evening Afterglow at Imado:* "Famous Places within the Eastern Capital: Eight Views of Sumida River."

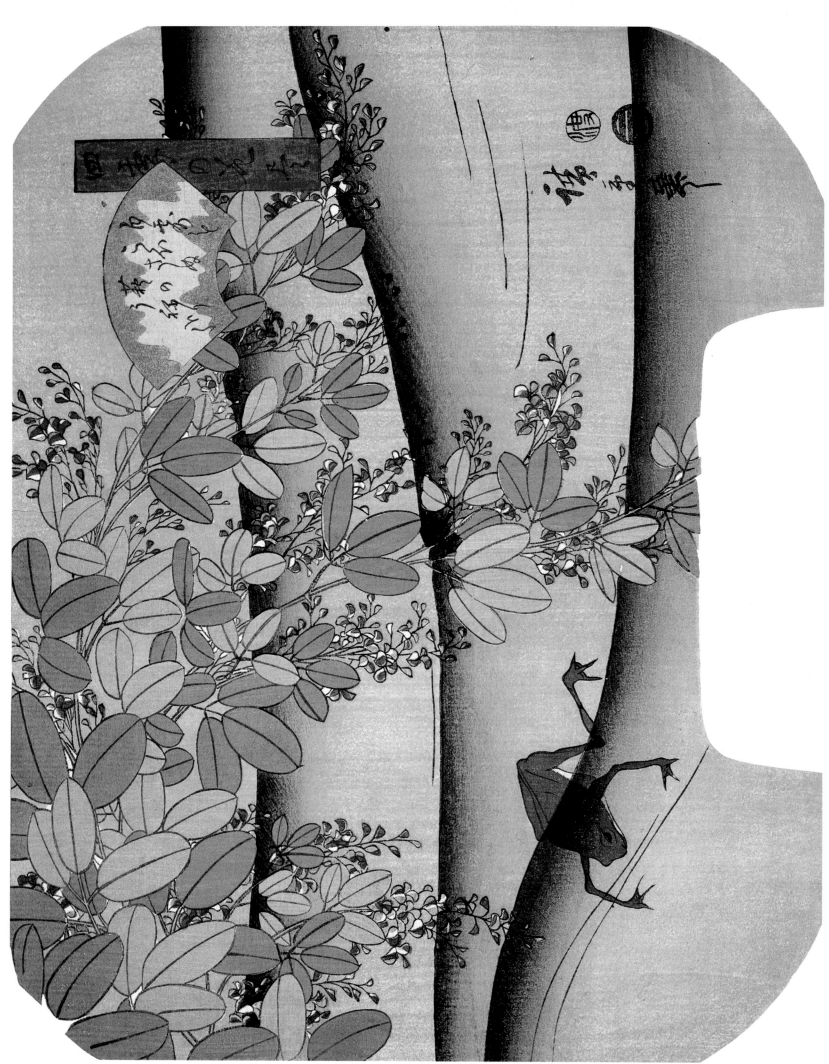

27. *Bush Clover and Frog:* "Flowers in the Four Seasons."

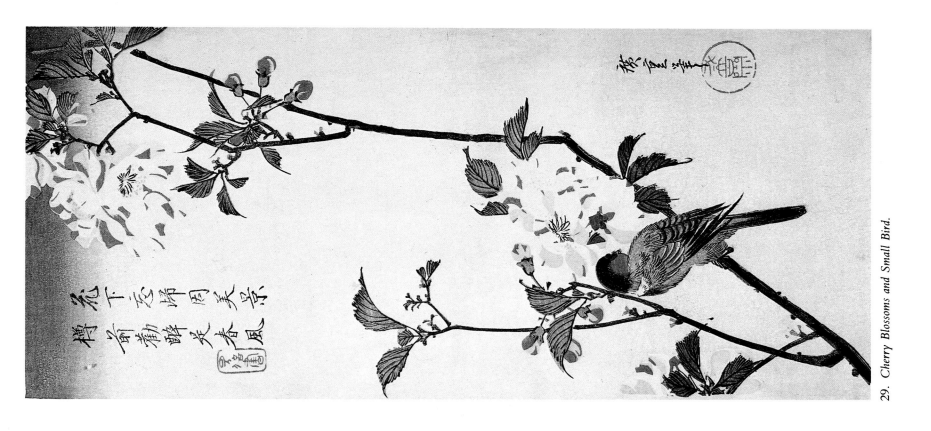

29. *Cherry Blossoms and Small Bird.*

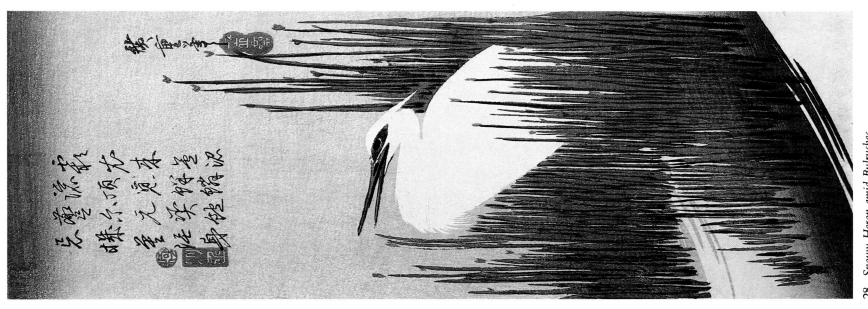

28. *Snowy Heron amid Bulrushes.*

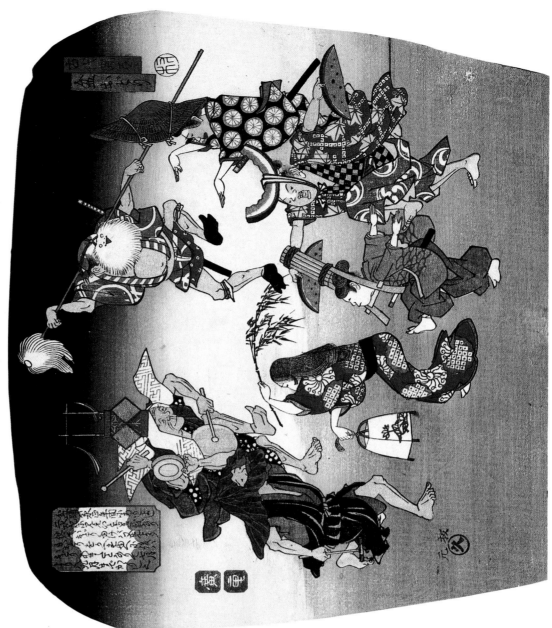

35. *The Bon Dance:* "A Compendium of Ancient Dances."

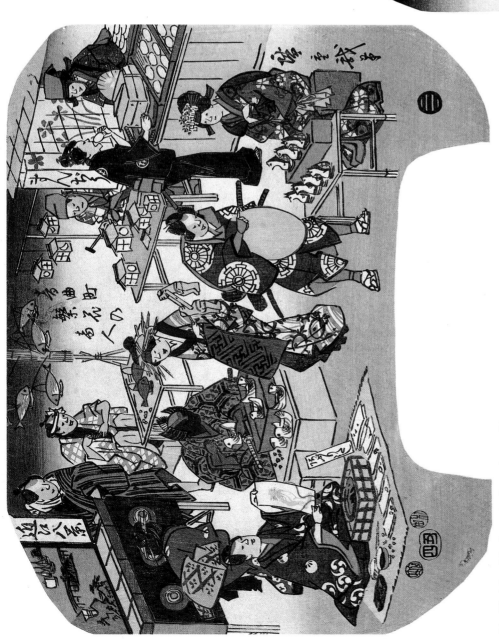

34. *Thriving Merchants in Ongyoku-machi.*

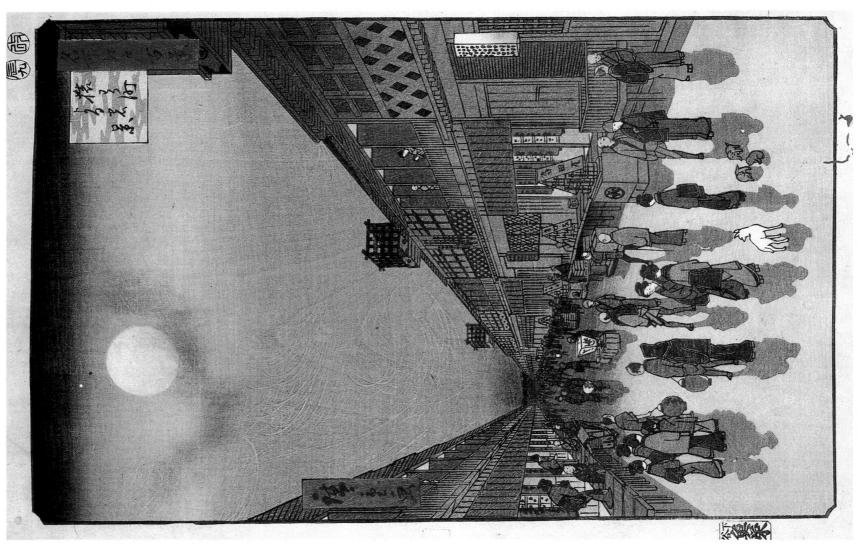

37. *Evening Squall on Great Bridge in Atake*: "Famous Places in Edo: A Hundred Views."

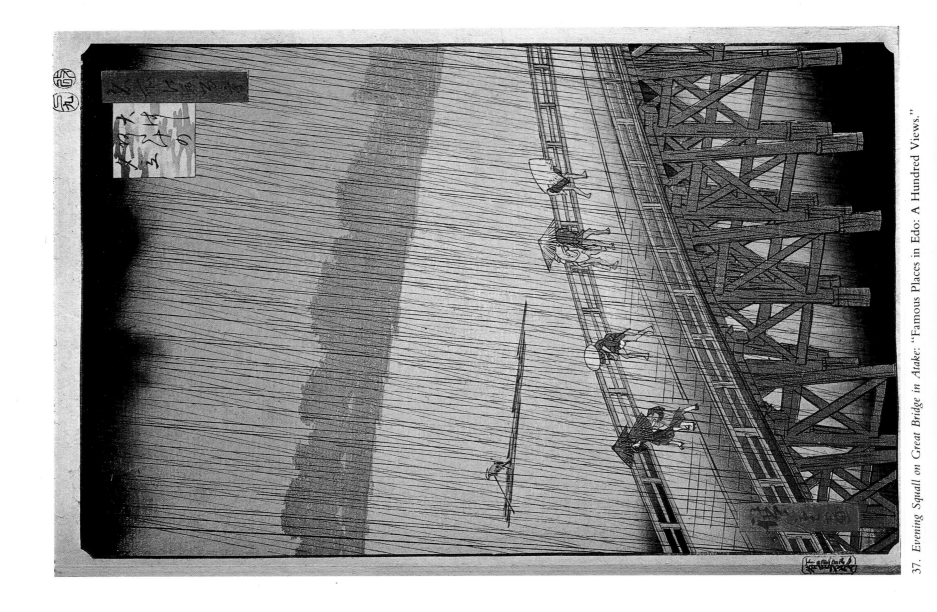

36. *Night Scene at Saruwaka-chō*: "Famous Places in Edo: A Hundred Views."

HIROSHIGE

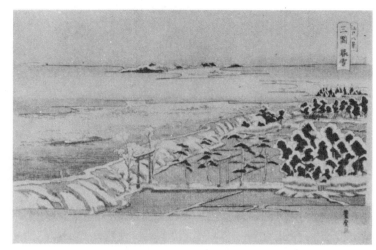

Fig. 1. *Evening Snow at Mimeguri*, by Hiroshige's teacher Toyo-hiro.

THE MAN AND HIS WORK

Utagawa (or Andō) Hiroshige, active in the first half of the nineteenth century, was the last great master in the Japanese tradition of woodblock printing known as *ukiyo-e*. While many *ukiyo-e* artists concentrated on perennially popular depictions of beautiful women or celebrated Kabuki actors, Hiroshige gave expression to his particular genius in the genre of landscape prints, presenting a genial, deeply poetic view of nature that was uniquely his own. These prints not only found a vast contemporary audience in Japan, but also proved a powerful influence on such Western artists as Whistler, Cézanne, and van Gogh.

What kind of man was Hiroshige, this painter of poetic landscapes? In the posthumous portrait appearing on the contents page of this book, he is portrayed as an eminently successful figure of commanding presence, of healthy if not sleek complexion. Over a formal kimono he is wearing a silk gauze cloak bearing his family crests, and he is seated grandly on a large cushion. This portrait, actually a woodblock print, is one of a type known as "death pictures," which were published and distributed as part of a memorial service for a deceased person. Such prints were often made for such celebrated figures as Kabuki actors and *ukiyo-e* artists, originally by disciples, friends, and acquaintances to express their respect and love. So it was with this portrait of Hiroshige, executed by the elegant brush of Toyokuni III, a close associate of Hiroshige's, and one can well imagine how Toyokuni would have been moved to depict his departed friend as a highly successful, influential personage. Despite the impression created by this portrait, however, it is not true that Hiroshige, as well known as he was in the popular culture of the day, lived a life of affluent ease surrounded by a large number of disciples.

Hiroshige, it is true, produced a vast number of prints during his lifetime. Uchida Minoru, in his book *Hiroshige*, notes that an actual count reveals over eight thousand items. But in this respect Hiroshige was not alone, for such nineteenth-century print artists as Toyokuni I and Kunisada were also very prolific. Moreover, though Hiroshige was extremely productive and, at the same time, so popularized the genre of the landscape that he is thought of as its creator, it is said that he was less well paid for his work than Kunisada and Kuniyoshi, who worked in the traditionally popular genres of beautiful women and Kabuki actors. In his work *Hiroshige*, Takahashi Seiichirō has this fair interpretation of the artist's life:

Throughout the sixty-one years of his life, this affable and industrious landscape artist was subject to the demands of the print wholesaler, contenting himself with low commissions amounting only to about twice the wages of a day laborer working on the offshore Shinagawa fortifications then being built in Edo Bay for the defense of the city. However, he worked quietly at producing paintings for the woodblock prints and, unlike other print artists, he never broke a contract with his publisher, never missed a deadline, but worked on assiduously to create more than eight thousand pictures, and yet his daily life apparently never became easy and comfortable.

In his will we find Hiroshige asking that money he had borrowed be repaid. On the other hand, he is invariably described as a man of easygoing disposition. He is also reputed to have been steady and methodical, traits that reflect perhaps his samurai background. Early in life he lost both parents and thus experienced a good deal of loneliness, but in considering the prints he produced during his lifetime, one imagines that he found peace of mind, not in the bright, gregarious life of the demimonde, as one might have expected, but rather in the world of natural beauty that he depicted in his landscapes.

AN UNHAPPY CHILDHOOD

Hiroshige was born in 1797 in the Yayosu Riverbank section of Edo (modern Tokyo). His father, Gen'emon, was the son of Mitsuemon, who was himself the third son of Tanaka Tokuemon, who held a position of considerable importance in the service of the powerful Tsugaru family in Mutsu (present-day Aomori Prefecture). Mitsuemon was an archery instructor who gave himself the sobriquet Sairyūken. Gen'emon, who became the adopted son of Andō Jūemon, succeeded his adoptive father as regular fire warden for the Yayosu Riverbank area, a lesser office of the central government in Edo which carried with it a salary rated as annual rations for two persons. Hiroshige's youthful name was Tokutarō, later changed to several other names: Jūemon, Tokubē, and for a time Tetsuzō.

Hiroshige's death occurred in 1858, and ten years later came the rapidly changing modern age of the Meiji era (1868–1912), when Japan was opened fully to the West. As might be expected of a popular *ukiyo-e* print artist living so close to this modern era, his travel diary has survived, as have such documents as lineages and records of relatives. Though it is the norm to know hardly anything about the biographies of

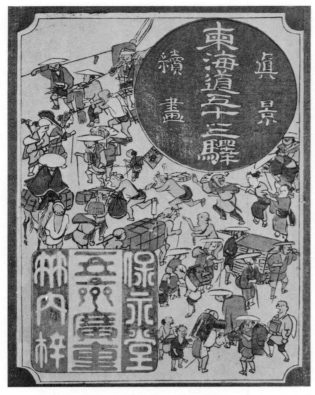

Fig. 2. Illustration on the wrapper of the complete set of "Fifty-three Stages of the Tōkaidō."

Fig. 3. Hiroshige's *Full Color Picture in the Modern Style*.

ukiyo-e artists—Sharaku and Utamaro being well-known examples—a variety of anecdotes related by persons who knew or were close to Hiroshige during his lifetime have been handed down to us, and in Hiroshige's case it is possible to trace his lineage and birth through a small body of extant materials. However, apart from such primary sources as his travel diary and his will, all the documents from the hands of later generations, including those relating to the Andō family, contain errors and must be used with circumspection. Still, we should consider ourselves fortunate to have such clues for a study of his life. We are further told that Hiroshige himself left behind a detailed autobiography, but this is said to have been destroyed by fire in 1876. With such an autobiography we might have learned about his parents or the circumstances that led him into painting; there are otherwise virtually no records about Hiroshige as a young man.

A painting of a procession of Okinawans done by Hiroshige when he was nine is said to have shown him already gifted with the brush, but there are scholars who doubt the painting's authenticity, and the work itself was lost to fire in 1923. And yet there are any number of documented cases of outstanding modern painters who showed a fondness for painting as children or were skilled above the average. Thus, with an artist of Hiroshige's caliber, it would come as no surprise if he had given evidence of a measure of genius from an early age.

Hiroshige's youth saw a good deal of unhappiness. In the second month of 1809, when he was twelve, he lost his mother. In the same month, perhaps because of illness, his father handed on to the young Hiroshige the position of fire warden. By the end of the year his father too had died. Hiroshige had no brothers, and of his three sisters we know from a temple register that his elder sister had died nine years earlier. Losing one of his sisters when he was three, his parents when he was twelve, Hiroshige, familiar at an early age with isolation and sorrow, began learning the job of fire warden, consoling himself in private, it is thought, by pursuing his fondness for painting.

THE YOUNG ARTIST

Just when Hiroshige began to study under the *ukiyo-e* artist

Utagawa Toyohiro is not clear, but in 1812, as the youth Andō Tokutarō, he was permitted by his teacher to use the surname of Utagawa, and it is known from a letter that he was also given the name Hiroshige, which he would use to sign his work. Accordingly, it is believed that, about one year after the deaths of his parents, around the age of fourteen, Hiroshige began his apprenticeship under Toyohiro.

Toyohiro and Utagawa Toyokuni were the two most outstanding disciples of Utagawa Toyoharu, founder of the Utagawa school. Toyohiro, Hiroshige's eventual teacher, was no inferior to Toyokuni in overall skill, but his elegant and refined portraits of beautiful women were obscured by the more showy style of Toyokuni, and his popularity lagged far behind. Hiroshige actually made an attempt to study under Toyokuni, the most popular artist of the day in the realm of prints of beautiful women and of Kabuki actors, but Toyokuni already had too many disciples, and Hiroshige was turned away. He was thus obliged to enter the school of Toyohiro, to whom he had been introduced by a well-to-do proprietor of a lending library.

We know nothing about what moved Hiroshige to become a print artist. Perhaps it was to help with his living expenses. Much speculation has been set forth, but I wonder if it is not appropriate to regard the impetus as quite simply the desire to do that which he most wanted to do. Rather than choose the officially supported Kanō school or the aristocratic Tosa school of painting, both boasting long traditions, it would seem that he felt an affinity for the *ukiyo-e* prints popular among the commoner class. Indeed, though he was descended from a samurai family, there is nothing in his works that gives one a sense of that background; his prints are always filled with a feeling for the commoner's daily life.

The prevention of fires in Edo castle, the responsibility of the particular type of fire warden whose position Hiroshige occupied, was normally a comparatively relaxed job, so that those engaged in it had considerable time for other activities. Hiroshige himself studied *ukiyo-e* on the side while holding the fire warden job, but it is doubtful he was aware at this time that he would set himself up as a print artist in the future. Even though he was eventually to study under Toyohiro, he

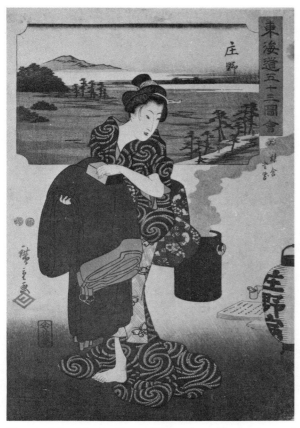

Fig. 4. Hiroshige's *Shōno*: "Fifty-three Illustrations of the Tōkaidō."

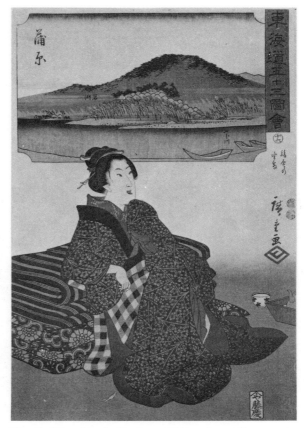

Fig. 5. Hiroshige's *Kanbara*: "Fifty-three Illustrations of the Tōkaidō."

also studied the Kanō school under Okajima Rinzō, his friend and a superior in the fire fighting brigade, and he looked into the rather informal and sometimes whimsical style known as Nanga, or Southern school, which had been brought to Japan from China early in the eighteenth century. In addition, he learned the realistic techniques of drawing from life from the Kyoto-based Shijō school. We may also infer rather easily from his early landscape prints that Hiroshige probably studied *uki-e*, Japanese pictures adapting Western perspective, as well as Western prints.

What sort of works did Hiroshige paint while he was studying under Toyohiro? In the beginning, he started with book illustrations, eventually progressing to work on single-sheet multicolored prints (*nishiki-e*) depicting actors, warriors, and beautiful women. In general, the training of a *ukiyo-e* print artist began with copying the master's book illustrations and multicolored prints (fig. 1), then moved gradually to the study of the work of other *ukiyo-e* artists, the rule being in the meantime to study brush technique and painting style found in various other schools, such as the Kanō and Shijō schools. In the Meiji period, Japanese-style and Western-style painters who entered the school of an *ukiyo-e* print artist were assigned the same training program. The first task as a new student normally was to do the illustrations in a woodblock-printed book since, compared to single-sheet prints, immaturity and mistakes would not stand out, and also because of the feeling that a new student's debut should come after he had had sufficient training in simple sketching.

Hiroshige's works during this period of his career include the illustrations for a book of comic poetry (*kyōka*), *The Lavender Volume of Kyōka* (*Kyōka murasaki no maki*), and several *gōkan*, or books in which the story was written as a series of pamphlets, liberally illustrated with woodblock prints, and then bound as a single volume. Among these *gōkan* are *Music, The Beginning Thread of Love* (*Ongyoku nasake no itomichi*), parts two and four of *Random Chatter, Ignorant Discussions* (*Dehōdai mucharon*), and one with a fanciful and untranslatable title, *Fude ayaito misuji no tsugizao*. Hiroshige's single-sheet prints included, besides actor prints, several warrior and history prints. Among his prints of beautiful women are the series

"A Mirror of Virtuous Courtesans" (*Keisei misao kagami*), "A Compendium of Present-day Women Lovely as the Goddess Benten" (*Ima-yō Benten zukushi*), and "Eight Glimpses of Women, Intimate and Remote" (*Soto to uchi sugata hakkei*).

The book *The Lavender Volume of Kyōka*, mentioned above, is quite rare. According to Uchida Minoru in his study *Hiroshige*, the brushwork is in the Kanō style, the illustrations in the form of rough sketches. Since the illustrations are signed Ichiyūsai, one of Hiroshige's signatures, and since the work bears the date 1818, these illustrations are now regarded as Hiroshige's earliest work. Also, in small framed insets within his "Compendium of Present-day Women Lovely as the Goddess Benten" he has drawn landscapes showing famous places in Edo that incorporate Western techniques.

Of Hiroshige's actor prints and depictions of beautiful women of this period, one might well say that they are as yet only copies of works by his teacher and older artists of the Utagawa school. They remain thoroughly in the Utagawa style created by such masters as Toyokuni and Kunisada. Judging from these works, one may regard Hiroshige as beginning to show himself as a print artist from around 1818.

It is thought that Hiroshige discovered himself as a landscape artist around the beginning of the 1830s and started using the signatures Ichiyūsai (different characters from his earlier signature but having the same pronunciation) and Ichiryūsai. Thus, from the beginning of his studies under Toyohiro in 1811 to his formal appearance in the print world as an artist it took eight years, and it was more than a decade later that he decided to concentrate on landscape prints. Around 1829 or 1830 he produced a series entitled "Eight Famous Views of Ōmi" and a ten-print series entitled "Famous Places of the Eastern Capital," and for the first time we see works that truly look like landscape prints, though artistically they are not particularly noteworthy.

It is known that in the meantime, in 1823 when Hiroshige was twenty-six, he resigned from his job as fire warden and handed the position over to his son Nakajirō. There are several problems as to whether or not Nakajirō was Hiroshige's real son, and how to interpret Hiroshige's early retirement, but in recent years one particular conjecture has been advanced.

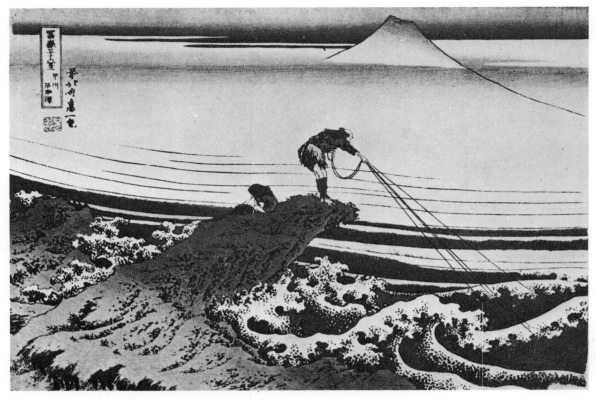

Fig. 6. Hokusai's *Kajikazawa in Kai Province*: "Thirty-six Views of Mount Fuji."

Starting from the statement by Uchida Minoru in his study of Hiroshige that Nakajirō was actually the son of Andō Jūemon, Hayashi Yoshikazu has theorized that Hiroshige's father, Gen'emon, after being adopted into the Andō family, produced an heir in young Tokutarō (Hiroshige), but later, when Nakajirō was born to the second wife of Andō Jūemon of the adoptive family, the position of fire warden was passed on to this true child of the Andō house. In any case, Hiroshige resigned from the office, but it was not because he wished to devote himself wholly to *ukiyo-e*, and for a while he continued to serve as Nakajirō's alternate. Later, in 1828, Toyohiro died and Hiroshige was urged to succeed to his name, but according to the authoritative *Lives of the Utagawa Artists* (*Utagawa retsuden*), by Iijima Kyoshin, Hiroshige declined.

Around 1830 Hiroshige altered his earlier print signature of Ichiyūsai by changing the characters used to write the name, though the pronunciation remained the same. In 1832 he changed the signature to Ichiryūsai. During the period he was using the new Ichiyūsai signature, his output of landscape prints grew, and it is noteworthy that at the same time he produced a large number of bird and flower prints. Around 1831 his series of ten prints "Famous Places of the Eastern Capital" was issued by the publisher Kawaguchi Shōzō, bearing the signature Ichiyūsai. This series may be considered the first work to demonstrate his genius as a landscape artist.

In the prints of this series, in *Takanawa beneath a Harvest Moon* (pl. 1) and *Ryōgoku under an Evening Moon* (pl. 2), for example, one is able to detect the influence of Hokusai in the manner of their composition. Since Hokusai's series "Thirty-six Views of Mount Fuji" (fig. 6) is recorded as having been published in 1831, it seems reasonable to assume that these first landscape prints by Hiroshige in *ōban* format were rather strongly influenced by Hokusai in terms of both composition and the motivation for their creation. "Famous Places of the Eastern Capital" is an outstanding work that is completely different from the smaller scale landscape prints that Hiroshige had attempted hitherto. In the pattern of the scenes, the quietude, the unassuming humility toward nature, one can detect already in these prints that special quality that is observable throughout all of Hiroshige's landscapes. This series is particularly noteworthy in that it seems to have brought home

to Hiroshige the realization that his true calling was that of a landscape artist. It was thus a godsend for Hiroshige, his eyes now opened through this series to a specialization in landscape art, that an opportunity to make a journey along the Tōkaidō should have presented itself.

In 1832, by some means or other, Hiroshige was able to join an official procession to Kyoto traveling over the Tōkaidō highway, the purpose of which was to deliver horses that were to be presented to the imperial court on the first day of the eighth month. This being the first time Hiroshige had traveled the Tōkaidō (Eastern Sea Road), the main thoroughfare between Edo and Kyoto, Hiroshige was enormously impressed, and sketched the scenery as he went. Upon his return to Edo he immediately set to work producing what was issued by the Hōeidō publishing house as "Fifty-three Stages of the Tōkaidō" (pls. 3–8, pp. 46–47), a series of prints depicting the fifty-three way stations along the Tōkaidō.

THE MATURE HIROSHIGE

The fifty-five prints of "Fifty-three Stages of the Tōkaidō" were first sold individually, then when the series was completed, in sets with paper wrappers bearing the title "True Depictions in Continuous Scenes of the Fifty-three Stages of the Tōkaidō" (fig. 2). This print collection contains a number of outstanding works, such as *Mishima*, *Numazu* (pl. 4), *Kanbara* (pl. 5), *Shōno* (pl. 6), and *Kameyama*. These prints with which Hiroshige began his career as a landscape artist are also among the best he produced throughout his life.

Later Hiroshige did a variety of series based on the Tōkaidō, many with identical or very similar titles, but the best of those dealing with the fifty-three stations is this published by Hōeidō (the first print was published jointly with the Senkakudō publishing house). Travelers walk a lonely road along a river in bright moonlight at Numazu (pl. 4). Others smack their lips over bowls of soup broth made of grated yams, a famous product of Mariko (pl. 3), where the crisp coloring of plum trees in bloom and young leaves coming forth fills the print with the bracing air of early spring; the woman serving food and the appearance of the farmers give an added sense of amiability to the scene. We enjoy with the travelers the varieties of scenes and local customs along the way; or, putting our-

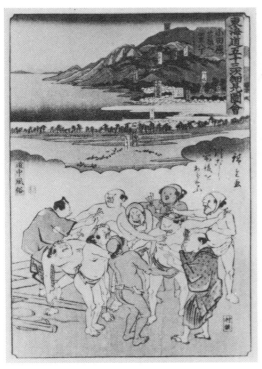

Fig. 7. Hiroshige's *Odawara*: "Illustrated Guide to the Fifty-three Stages of the Tōkaidō."

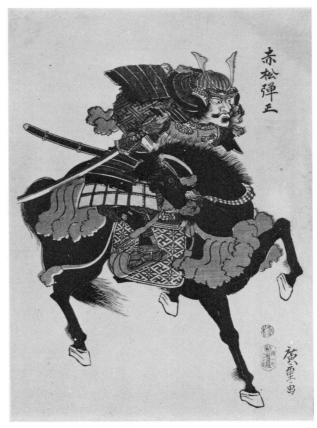

Fig. 8. Hiroshige's *Akamatsu Danjō*.

selves in the place of the figures in the prints, we walk the roads, feel fear at the darkness of the mountains, pause at a hostelry on a snowy night. The pleasure derived from such pictures as these is something quite apart from their artistic quality or value, it is more instinctive, a sort of primal joy, and this is the most important element in any picture for the common people. Herein, I think, lies the reason that the *ukiyo-e* print will forever continue to be a living force among the general public.

Although Hiroshige's depictions of the Tōkaidō show the scenery seen along its route, virtually none of the pictures depict scenery alone. There is always "the road," with persons in traveling garb and other people appropriate to the locality sketched in, creating a scene based on the road leading to or passing through a way station. The image of the highway itself is never lost. The same is true of his series "Sixty-nine Stages of the Kisokaidō." Although there are instances where the people are of interest chiefly as representatives of local customs and manners, they always form one element of the landscape, one scenic unit, making an important contribution to the effectiveness of the whole. If one mentally conceives of the print *Mitsuke* (pl. 8) devoid of human figures, one will be astonished at how important is their function in this picture, and will be struck anew at the skill with which they are placed in the composition. Particularly noteworthy is the way Hiroshige always sketches in people of the different localities, showing each one in an activity or attitude appropriate to that place. Whether it be the boatman with his bean-shaped pipe in the print *Mitsuke* or the farmer shouldering a hoe in *Mariko* (pl. 3), Hiroshige has deftly captured the appropriateness of the person to the place, drawing them in with a lifelike quality.

The figures Hiroshige uses to populate his pictures draw the viewer into the scene before he is aware of it, but any overt statement is softened and muted, for the figures themselves make no strong assertion of their existence. Hiroshige appears to have thoroughly disliked obvious pronouncements. Even while working in the same landscape genre as Hokusai, what a difference there is in the way Hiroshige treats the figures in a scene!

Since it first went on sale, the number of printings of Hiroshige's "Fifty-three Stages of the Tōkaidō" is past knowing.

There have probably been few works of art that have been so continuously popular as this one. Of course, the popularity of the work at the time it was first published was dependent upon its charm as a work of art, just as had been the case with the Kawaguchi edition of "Famous Places of the Eastern Capital" before it (pls. 1–2); and yet there were also important historical reasons for the success of this series. One may mention the novel *Going by Shank's Mare along the Tōkaidō* (*Tōkaidōchū hizakurige*) by Jippensha Ikku as a considerable influence. The first part of the book was published in 1802, and the comic tales of the misadventures of two Edo characters trekking the Tōkaidō became a great hit. As the novel came to be widely read by the commoner class, the Tōkaidō acquired a certain familiarity among the lower classes in general. The stories of the unusual travels of the main characters Yaji and Kita, with the Tōkaidō as their stage, meant that by the time of Hiroshige's prints it had already been shown that a lighthearted journey along the Tōkaidō was quite feasible. Maps, guide books, travel information books, and other similar works were published in a variety of forms, not only for the Tōkaidō but for other routes as well. More than anything else, the large-scale travel of the great feudal lords moving to and from Edo in their compulsory alternate-year attendance at the shogun's court had resulted in the development of roads, hostel accommodations, travel vehicles (mainly palanquins and horses), river crossing facilities, and the like. Travel became both safe and convenient, making it easy for the plebeian class to get about.

In this age there was a good deal of travel, for sight-seeing in Kyoto, pilgrimages to Ise, religiously inspired journeys to Mount Fuji and Ōyama, and trips to nearby provinces on business or for health reasons were very popular. In the latter years of the Edo period (1600–1867), the entertainment life of the lower classes moved more broadly outdoors, beyond the traditional worlds of the Kabuki theater and the pleasure quarters. People were inspired to travel in search of a sense of emancipation or to visit places they had never before seen, and the epitome of travel must have been the Tōkaidō. Hiroshige's depiction of the Tōkaidō, and Hokusai's before it, reflect the demands of the age.

Hiroshige, who had now strengthened his self-confidence in

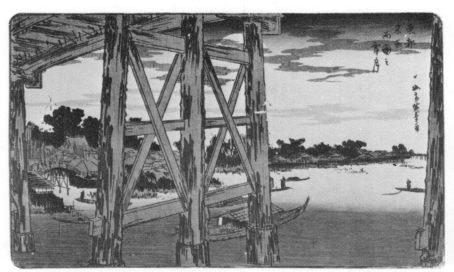

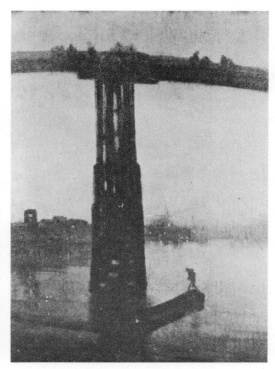

Fig. 9. Hiroshige's *Ryōgoku under an Evening Moon*: "Famous Places of the Eastern Capital."

Fig. 10. Whistler's *Old Battersea Bridge*.

landscape prints through the production of his "Fifty-three Stages of the Tōkaidō," gave rein to his brush and began to create in succession superbly crafted works on the famous places of Edo. And along with them came publication of prints of famous scenes from the Kyoto-Osaka region (the so-called Kamigata area), such as the ten-print set "Famous Places of Kyoto," "Eight Famous Views of Ōmi Province," and the ten prints known as "Illustrated Famous Places of Naniwa [Osaka]." "Famous Places of Kyoto" (pls. 9–10) and other landscape prints of Kyoto and Osaka were probably projects initiated by publishers following the favorable response to "Fifty-three Stages of the Tōkaidō." Hiroshige had traveled to Kyoto, but it is doubtful he had had the time to make the rounds of all these famous places. Mixed in among his prints of these Kamigata scenes are ones thought to be based on illustrations found in previously published books, but several of them are fine pieces, done while Hiroshige's powers were in their ascendance.

"Eight Famous Views of Ōmi Province" treated subjects found in ink paintings since ancient times, and Hiroshige himself described this work as "a series of pictures done in muted colors in the style of the old monochromes." With these earlier faint ink washes as his basic pattern, he created a unity of tone both calm and invigorating. *Night Rain at Karasaki* (pl. 14), with its ancient pine tree seen looming indistinctly in a heavy rain, and the print *Evening Snow at Hira* are perhaps the finest pieces in this eight-print series. *Night Rain at Karasaki*, better known in the version done entirely in black ink, is here illustrated in the extremely rare blue tone (*aizuri*) variant, a work with a rather unusual effect.

From around the year 1834 to near the end of his life, Hiroshige produced a great many series on the famous places of Edo, issued by a variety of publishers under at times identical titles (pls. 11–13, 20–21, 24–26, 30–33, 36–37), but the series published by Kikakudō encompasses a number of well-wrought prints and must surely be the best of the lot (pls. 22–23).

Among Hiroshige's medium-sized vertical prints known as *chū-tanzaku* (approximately 39 cm. by 13 cm.), his "Famous Places of Edo in the Four Seasons" (published by Kawaguchi Shōzō; pls. 30–33) dates from about 1834. And from 1832 to about 1838, apart from his efforts in landscape prints, he set his brush to a considerable number of bird and flower pictures (pls. 28–29). Many range in size from these *chū-tanzaku* to the

larger *ōtanzaku* (approximately 39 cm. by 17 cm.), works employing bright colors and achieving decorative effects. In his landscapes Hiroshige used few colors, and the colors themselves are employed with restraint; in the bird and flower prints, however, he let himself go and gave full play to the effects of bright pigments. In these numerous prints where, in the manner of a watercolor, he painted directly in color, without outlining the birds or flowers in black ink, one feels all the more that he was searching for ways to bring the colors themselves alive. There is the feeling that, in contrast to the landscapes, he was suppressing as much as possible the use of black ink. Perhaps when his interest moved to color, he turned to prints of birds and flowers as an outlet. Many of these prints seek their motifs in Chinese-style poems (*kanshi*) and in Japanese *waka* poetry and comic *kyōka*, which are written in the upper portion of the picture. But in some prints there is only a remote connection between the motifs and these writings. As an *ukiyo-e* artist, Hiroshige moved among many literary men of the day, and these prints give us a glimpse of his cultural milieu. In general, however, these smaller *tanzaku* prints of birds and flowers are believed to show him savoring a personal taste.

Having established his own unique style with his "Fifty-three Stages of the Tōkaidō," Hiroshige went on to devote himself fully to landscape prints, seeking the limits of personal growth within the confines of this genre. His two series "Eight Views of the Edo Environs" (pls. 11–13) and "Sixty-nine Stages of the Kisokaidō" (pls. 15–19), thought to have been produced sometime around 1838, are works which grew out of a period of Hiroshige's most substantial production, a continuation of the works dating from about 1834 which have been noted above. "Eight Views of the Edo Environs" might be called a work done in collaboration with writers of comic *kyōka* poems, since *kyōka* by several poets appear at the top of each print, and it is believed that Hiroshige's association with a group of literary figures, including such *kyōka* poets as those represented in these prints, exerted no small degree of influence on him personally and on his prints.

The series "Eight Views of the Edo Environs" was made to be distributed by *kyōka* poets among their friends, one such poet being a man who styled himself Taihaidō Nomimasu, a facetious name that might be translated as "Drinker of the Great Wine Cup." Nomimasu was the original publisher of "Eight Views of the Edo Environs," and one of his comic

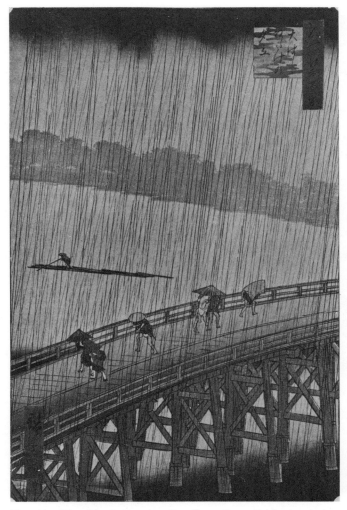

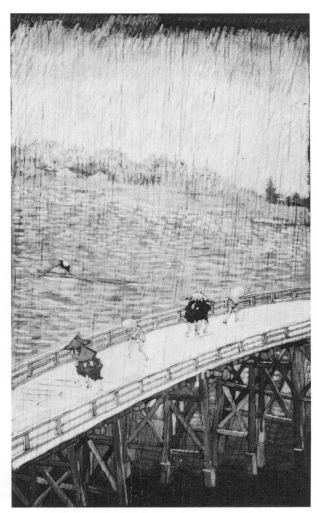

Fig. 11. Hiroshige's *Evening Squall on Great Bridge in Atake*: "Famous Places in Edo: A Hundred Views."

Fig. 12. Van Gogh's copy of Hiroshige's *Evening Squall on Great Bridge in Atake*.

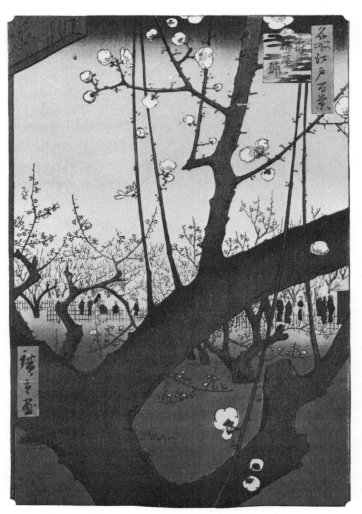

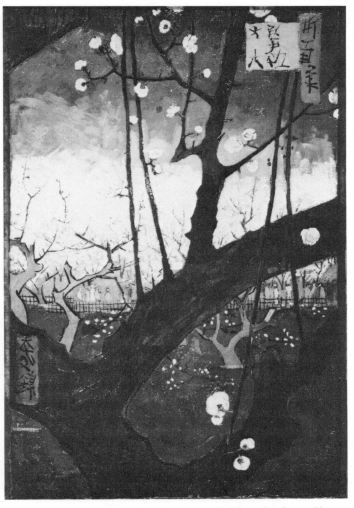

Fig. 13. Hiroshige's *Plum Garden at Kameido*: "Famous Places of Edo: A Hundred Views."

Fig. 14. Van Gogh's copy of Hiroshige's *Plum Garden at Kameido*.

verses appears at the top far left of the print *Evening Snow at Asukayama* (pl. 13). These prints with their *kyōka* poems and such prints as illustrated calendars were works produced for contemporary *kyōka* poets and other dilettantes who sought to satisfy their fancies, regardless of cost. They taxed their own inventiveness in supervising the carving of the blocks and then the actual printing, and in carefully selecting both paper and inks; and the artist too spent much time on the work trying to display his skills. Many of the prints are thus outstanding works. Whether it be *Autumn Moon over Tamagawa* (pl. 12),

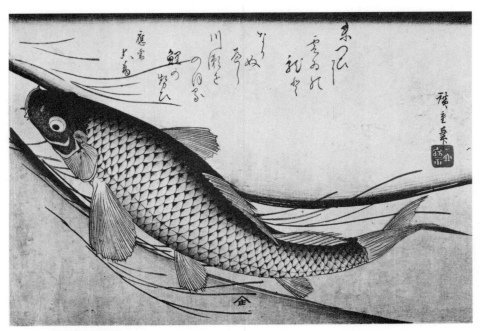

Fig. 15. Hiroshige's *Carp*: "A Compendium of Fish."

Evening Snow at Asukayama (pl. 13), *Returning Sails at Gyōtoku* (pl. 11), the quiet elegance of faintly red cherry in full bloom in *Evening Afterglow at Koganei*, or *Geese Landing at Haneda*, the series "Eight Views of the Edo Environs" is a collection of masterpieces, refined in their use of black ink and blues, works that show superbly meticulous care in the carving of the blocks and in the printing.

A work of almost the same time as "Eight Views of the Edo Environs" is the series "Sixty-nine Stages of the Kisokaidō," created jointly by Hiroshige and the artist Keisai Eisen. The division of prints between the two artists is uneven and without order. Hiroshige bore the heavier load, doing forty-six prints (there being one variant print of *Nakatsugawa*), while Eisen painted twenty-four. Moreover, there were two publishers for the series, Hōeidō and Kinjudō, some prints being published jointly and others independently. There are various interpretations as to the doubling of artists and publishers, but at present there are no documents available that present conclusive evidence. Interestingly, we have nothing to prove that either Eisen or Hiroshige actually traveled the Kisokaidō, which was a mountainous highway (*kaidō*) between Edo and Kyoto, running for some distance along the Kiso River and having sixty-nine way stations.

Among the forty-six prints by Hiroshige there are such outstanding examples as *Seba* (pl. 19), *Karuizawa* (pl. 15), *Mochizuki* (pl. 16), *Nakatsugawa, Tarui* (pl. 18), *Nagakubo*, and *Mieji* (pl. 17). Mixed in, however, are some prints that compare less favorably and some, such as *Miyanokoshi* and *Ashida*, that have unusual technical features. It is surmised that the series was initiated in 1835 because Eisen's print of Nihonbashi in Edo, one terminus of the Kisokaidō, contains the zodiacal character for sheep, appropriate to the year 1835. Still, there were difficulties between the publishers and the artists, and a rather long time was required for the completion of the series, which occurred around 1842. This would account for the uneven quality of the prints, their lack of consistency, and want of a unified point of view.

Hiroshige, having discovered through "Fifty-three Stages of the Tōkaidō" the print genre he most wished to pursue, was like a fish that had found water, and he vigorously pushed forward with his work in landscapes. During the space of some five years, with 1838 as the high-water mark, he produced nearly all of his best pieces. Following the series "Sixty-nine

Stages of the Kisokaidō" came a profusion of superb works, including the series "Eight Views of the Eastern Capital," in which the prints were made to be pasted on folding fans (*ōgi*), and the series "Eight Views of Hostelries, Close-up and Distant" (*Omote-ura ekiji hakkei*) for nonfolding fans (*uchiwa*). "Famous Places of the Eastern Capital" (pl. 20) and "Famous Places within the Eastern Capital: Eight Views of Sumida River" (pl. 25), both published by Sanoki, also came from the latter part of this period. One may also mention "Eight Views of the Eastern Capital: Shiba District" (*Tōto Shiba hakkei*) and "Famous Places of Japan" (*Honchō meisho*), as well as the diptychs *Sarubashi, Kai Province* (*Kai Sarubashi no zu*) and *Snow Scene of the Fuji River Headwaters* (*Fujigawa jōryū no sekkei*). In addition, there were two more series on the fifty-three stages of the Tōkaidō. One, since it contains *kyōka* poems, is commonly known as the "*Kyōka* Tōkaidō"; the other is called the "*Gyōsho* Tōkaidō," from the semicursive style (*gyōsho*) of the characters used to write the print titles.

During the Kōka era (1844–48) Hiroshige also began making prints of beautiful women, a genre he had not worked in since his early years as an artist, but this time the women were placed against backgrounds of famous places, probably an idea advanced by a publisher (figs. 4–5). His landscapes of this time included yet another series on the Tōkaidō, this one known as the "*Reisho* Tōkaidō," from the squared antique style (*reisho*) of the characters in the titles, and a series named "Famous Places in the Sixty-odd Provinces." Of special note is the eight-volume series of illustrated books titled *An Edo Souvenir in Pictures* (*Ehon Edo miyage*).

The series "Famous Places of Edo: A Hundred Views" (in 118 sheets; pls. 36–37, fig. 13) is a work that shows Hiroshige's efforts during the last phase of his career between 1848 and his death in 1858. The sense of poetry has dimmed, however, and his dominant theme has undergone a change: one is now struck by the forcefulness of color and a carving and printing of the blocks that shows great attention to technique. The finest print of this series is *Evening Squall on Great Bridge in Atake* (pl. 37). Besides this series, probably the outstanding works of Hiroshige's last years are the three triptychs *Mountains and Rivers of the Kisokaidō* (*Kisoji no yamakawa*), *Seascape of Naruto Strait in Awa Province* (*Awa Naruto no fūkei*; fig. 16), and *Nightscape of Kanazawa in Musashi Province* (*Musashi Kanazawa hasshō no yakei*).

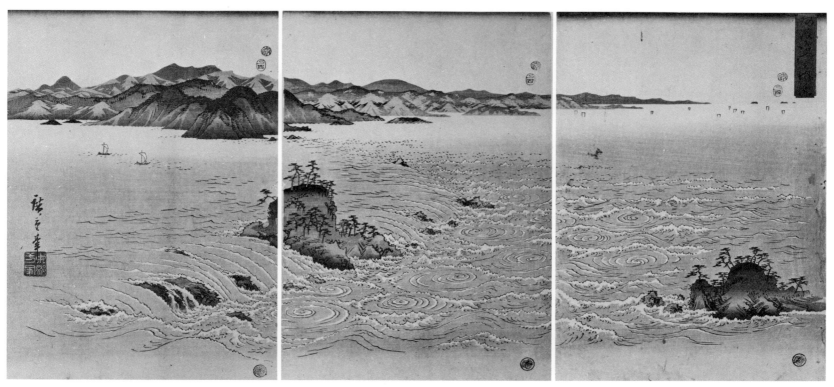

Fig. 16. Hiroshige's triptych "*Seascape of Naruto Strait in Awa Province.*"

COMPOSITION AND TECHNIQUE

I should like to touch briefly upon Hiroshige's characteristic composition and technique, taking some outstanding examples of his work from the period when he was in his prime. Attention tends to be focused on the lyrical qualities of Hiroshige's prints, with the carefully thought-out structure that supports such lyricism overlooked. Thus, although here and there I have referred to this subject, I would now like to treat it in a little more detail.

First, let us take up *Autumn Moon over Tamagawa* (pl. 12). The full moon has just begun to rise. The branches of a willow tree, while establishing a link with the moon by partially covering its face, trail in a gentle curve down toward the lower left. At the tips of the downswept branches is a single boat, the two elegant gentlemen in the boat looking upward at the moon. Further in the direction in which the branches sweep is a man who appears to be a fisher, and continuing to the left are placed two fishermen pulling on a net. Moreover, the net maintains a resonating curve of line with the willow, so that from the moon leftward, all the way to the human figures, there is a connecting line that is both highly successful and extremely natural. Through this skillful arrangement, our eye is led from the moon to the curve of the willow branches, to the figures in the river, and then on further to the distant scene at the composition's far left, making us feel there the expanse of distance and space. And Hiroshige gives variety to the figures too: he has some standing, some crouching, one looking to the left, others upward; and he eliminates from the scene every unnecessary object. So much the more, then, does his terseness of depiction create a wider and wider sense of space.

It should also be noted that Hiroshige has composed this print so that the left and right sides differ completely in terms of the density of the objects portrayed. As may be seen by dividing the picture in half and alternately covering each half, the right half contains the willow and the reeds, and in the middle distance are woods and houses, all painted forcefully and in detail with black ink. Against this, in the left half of the picture both dark ink and lighter washes are employed; there are no shrubs or trees, the uninterrupted expanse of the riverbed creating a broad open space from the foreground to the distant scenery. Half of the print is filled with objects from foreground off into the distance; the other half principally creates an extensive open area, moving across river and fields to link with the distant scenery. This novel composition with its left-right contrast is a characteristic one that Hiroshige was fond of using, a combination in which there is variety in picture format and differing density of portrayed objects left and right, and occurs often in his quest for a perspective effect.

The print *Seba* (pl. 19) is a masterful piece of composition. The horizon line extends left and right the breadth of the scene. Then from the lower left the line of the bank moves toward the extreme right of the horizon and, reinforced by the movement of the boat, slowly and deliberately leads our sight at an angle into the picture, the artist achieving an expression of a vast sense of space. Both the reeds at the water's edge and the branches of the trees bend in the breeze, inviting the eye naturally from left to right. Such movement makes one fairly feel the blowing of the wind. Behind the painstaking brushwork of each branch of the willow, each leaf of the reeds, one can almost sense the presence of the artist, the man himself.

A quiet lyricism is one of the great charms of Hiroshige's landscapes, but Hiroshige was not one to let his poetic sensibility run riot. His works are always built upon a tightly constructed framework. The skill in compositional contours, the freshness seen in his *Autumn Moon over Tamagawa*, stand out among the work of contemporary artists. *Ukiyo-e* landscape prints got their start in Hokusai's hands; but Hokusai, in his violent individuality, had a weakness for the strong brushwork and vigor of Chinese-style paintings, creating peculiarly shaped mountains with rugged and bony crags. Hiroshige, who sought a quietude within nature, who loved tranquility, was also a man who enjoyed *kyōka* and *haiku* poetry, and one feels that it was this spirit that became one of the hallmarks of his landscape prints. It is also characteristic of Hiroshige's landscapes that he always brings to his paintings a sense of the season. Perhaps one may say that Hiroshige was a poet of the gentle beauty, the stillness of Japan's natural features. Surely it is this warm relationship with a nature that envelops human life that has summoned forth a sympathetic response from such a broad range of people.

Notes on the Color Plates

1. *Takanawa beneath a Harvest Moon*, from the series "Famous Places of the Eastern Capital" (*Tōto meisho: Takanawa no meigetsu*). *Ōban* size. Published by Kawaguchi Shōzō, *ca.* 1831.
This series consists of ten prints, each bearing the inscription "Picture by Ichiryūsai Hiroshige," and each set in a frame. In *Takanawa beneath a Harvest Moon*, with a flock of geese painted in large at the center of the scene, there is a boldness of composition that is frequently seen in this series, as in the way the bridge girders are brought full into the foreground in *Ryōgoku under an Evening Moon* (pl. 2). The technique is thought to be an influence from Hokusai. Rather than trying to take the viewer by surprise, however, in the manner of Hokusai, Hiroshige seems to aim at painting a broad expanse of open space through the contrast between foreground and distant scene. This series represents Hiroshige's first essay in the field of landscape prints in *ōban* size and presents a fresh youthful style. Through it Hiroshige discovered in landscapes the genre most congenial to his temperament.

2. *Ryōgoku under an Evening Moon*, from the series "Famous Places of the Eastern Capital" (*Tōto meisho: Ryōgoku no yoizuki*). *Ōban* size. Published by Kawaguchi Shōzō, *ca.* 1831.
This print is one of two variants. The one usually illustrated has the cross-supports of the bridge and the houses on the far shore printed in ochre. Here I have chosen to include the less commonly seen version printed principally in indigo (*aizuri*), of which there are others in this series. A group of red clouds lying low near the horizon in the ochre print has been completely eliminated from this variant. Various persons have pointed out Hiroshige's influence on the American artist Whistler, and this print reminds one of Whistler's painting *Old Battersea Bridge* (fig. 10).

3. *Mariko*, from the series "Fifty-three Stages of the Tōkaidō" (*Tōkaidō gojū-san tsugi no uchi: Mariko*). *Ōban* size. Published by Hōeidō, 1832–34.
Here Hiroshige has depicted against a pastoral landscape a store selling Mariko's famous broth made of grated yams—the leaning sign in front of the shop advertises the product. The conception of the scene perhaps came from the story of the comic travelers Yaji and Kita in the novel *Going by Shank's Mare along the Tōkaidō* and from Bashō's *haiku*:
> Young leaves of plum,
> And at the Mariko way station
> A broth of grated yams.
The red shading of the sky and the fresh green deftly printed in at the foot of the mountain give one a sense of the refreshing quality of early spring, that seasonal touch Hiroshige always gives to his landscapes. The first edition of the print used different characters for the name Mariko written in the upper left; otherwise, later printings show no noticeable differences from the original.

4. *Numazu*, from the series "Fifty-three Stages of the Tōkaidō" (*Tōkaidō gojū-san tsugi no uchi: Numazu*). *Ōban* size. Published by Hōeidō, 1832–34.

Walking at night along the road toward the way station are a parent and child on a pilgrimage as well as a man carrying on his back a large mask of the legendary god Sarudahiko, on a visit to the Kinpira Shrine. The road bends and leads off to the left. Ahead walk other travelers, their heads drooping, while the bridge leads our eye further into the line of houses of the way station. We, the viewers, walk the road along with the travelers, feeling the distance, for the composition conveys a sense of depth. Above the line of houses a large full moon is starting its ascent. A subtle tone achieved solely through the use of blue and black inks works well in imparting the darkness of the night and the brightness of the moonlit atmosphere. The surface of the water is also light, perhaps from the moon, and the whole is a quiet and lonely roadway landscape.

5. *Kanbara*, from the series "Fifty-three Stages of the Tōkaidō" (*Tōkaidō gojū-san tsugi no uchi: Kanbara*). *Ōban* size. Published by Hōeidō, 1832–34.
There are two versions of this print. One has a dark ink band at the top of the print, shading off into a bright sky of faint gray at the bottom; the other, reproduced here, is completely the reverse: the lower sky touching the houses and the mountains is printed in black ink and shades off into a lighter upper sky. The former is regarded as the first printing, but the later printing is illustrated here because it conveys more tellingly the deep and hushed quality of the night and the beauty of black and white. The loneliness of the snowbound way station asleep in the depths of night, and the figures that lend a human interest to the scene, all warm the heart of the viewer.

6. *Shōno*, from the series "Fifty-three Stages of the Tōkaidō" (*Tōkaidō gojū-san tsugi no uchi: Shōno*). *Ōban* size. Published by Hōeidō, 1832–34. Tokyo National Museum.
The scene, rare for Hiroshige, is one depicting violent motion. The ferocity of the rain is conveyed through its thick skeins and the sharp angle of descent, with alternating areas of heavy and lighter downpour. A certain order has been established in the movement of the trees. The thicket in the background, bending with a shudder under a sudden gust of wind, stretches from right to left in sheets of gray, giving a feeling of powerful movement. Hiroshige has delineated in masterly fashion the turbulence of the torrent through a skillful capturing of the people in their hurry-scurry and the commotion in the surroundings brought on so suddenly by the cloudburst. With the bright grass color on the ascending path, he has added a seasonal touch.

7. *Fukuroi*, from the series "Fifty-three Stages of the Tōkaidō" (*Tōkaidō gojū-san tsugi no uchi: Fukuroi*). *Ōban* size. Published by Hōeidō, 1832–34. Riccar Art Museum, Tokyo.
A rude tea shop sheltered by a reed screen is depicted alongside the road some distance from the way station. In the left half of the print Hiroshige has drawn in a foreground containing the tea stall, people, and a tree; in the right half he has built up a broad expanse of open space. The composition is one Hiroshige was fond of using, with its contrast between left and right, between distant vista and fore-

ground, and between sparseness and density of the objects portrayed. Travelers stop for a smoke as the mistress of the tea stall stirs the fire while avoiding the smoke. The setting might be seen anywhere along the road, and one should note the skill with which the behavior and appearance of various people are depicted. In the rather simple right half of the scene, the small bird on the signboard is perfectly placed.

8. *Mitsuke*, from the series "Fifty-three Stages of the Tōkaidō" (*Tōkaidō gojū-san tsugi no uchi*: *Mitsuke*). Ōban size. Published by Hōeidō, 1832–34.
Mitsuke was a way station east of the Tenryū River. People traveling from the Kyoto-Osaka region, the so-called Kamigata, to Edo got their first glimpse of Mount Fuji from here, and so the place is said to have been called "Mitsuke," or "Catching Sight." The picture depicts the ferry crossing at Tenryū River through a drizzling rain. The travelers waiting on the sandbar for the boat are wrapped in rain cloaks, and the horse has its pack similarly prepared for rain. The vista beyond the river is obscured by the drizzle. The boatmen in the foreground, with their backs to the viewer, have that amiable appearance that is characteristic of Hiroshige's figures. Though this is a landscape, the role played by the human figures in the foreground and middle distance is exceptional; without them the picture would lose all vitality.

9. *Yodo River*, from the series "Famous Places of Kyoto" (*Kyōto meisho no uchi*: *Yodogawa*). Ōban size. Published by Eisendō, *ca.* 1835.
The people on the boat have been portrayed most interestingly: a woman cradles a nursing infant, a man leans on one elbow and dozes, a pilgrim dressed in white and on a pilgrimage to Mount Kinpira shakes off his drowsiness. There is a variety of movement in the boatmen of the larger vessel, and the smaller boat alongside selling food is minutely rendered. The so-called thirty-*koku* (about 150 Western bushels) boat, drawn stoutly with the details of its construction clearly delineated, has numerous passengers on board but nonetheless rides steadily. The people on board, their behavior and peculiarities, would seem to be the center of interest, but the downriver journey is skillfully tied to the natural surroundings through the lucid indigo of the sky and water surfaces, with their shaded areas and the light of a full moon.

10. *Cherries in Full Bloom at Arashiyama*, from the series "Famous Places of Kyoto" (*Kyōto meisho no uchi*: *Arashiyama manka*). Ōban size. Published by Eisendō, *ca.* 1835.
The trees on the far bank, the green along the water's edge, even the smoke from the fire on the raft, all slant off obliquely toward the right, the entire composition moving gently from left to right. The scene is a peaceful one in which a raft moves slowly downstream amid a shower of cherry blossoms. In the thin black ink wash of the far bank, only the cherries are bright and lovely, echoing the bright beginning of the indigo on the river. It is a fresh new form of composition, in which the river is drawn in broadly, the far bank with the flowering cherries portrayed obliquely. Although a number of prints in this series of ten are based on illustrations available in such previously published works as *Illustrated Famous Places of Miyako [Kyoto]*, those presented here are of especially high quality.

11–12. *Returning Sails at Gyōtoku*; *Autumn Moon over Tamagawa*: from the series "Eight Views of the Edo Environs" (*Edo kinkō hakkei no uchi*: *Gyōtoku kihan*; *Tamagawa shūgetsu*). Ōban size. Published by Kikakudō, *ca.* 1835–39. Riccar Art Museum, Tokyo.
The early printings of this series included comic *kyōka* poems, as in these two prints, and were distributed among those with a fondness for *kyōka*. There is thus a close relationship between the picture and the accompanying poems. Later, however, the prints were issued without the poems. In *Returning Sails at Gyōtoku*, only the boat, placed at an angle in the foreground, exhibits a sense of motion amid the peacefulness of a composition made up largely of vertical and horizontal lines. This print represents one of the brighter scenes among the eight views of the series. In the first printing of *Autumn Moon over Tamagawa*, the moon was printed in silver. See plate 13 for a work from the first printing of this series.

13. *Evening Snow at Asukayama*, from the series "Eight Views of the Edo Environs" (*Edo kinkō hakkei no uchi*: *Asukayama no bosetsu*). Ōban size. Published by Taihaidō, *ca.* 1835–39. Ōta Memorial Museum of Art, Tokyo.

The workmanship in this print relies on the varying tones of light black ink. Owing to technical difficulties in producing shading, slight differences occur in this picture depending on the particular printing. The fact that every print possesses in its own way a well-balanced tone is probably attributable to the meticulous care lavished on the printing of this series. The characters printed into the left margin, "Published by Taihaidō," appeared on the first printing, which was created in a small edition to be distributed among friends and is rarely seen today. Since the continuously falling snow was painted in by brush on each print, it follows that there are no two prints in which the snow is the same. In the version that went on general sale, it is no longer snowing. See plates 11–12 for works of a later edition of the same series.

14. *Night Rain at Karasaki*, from the series "Eight Famous Views of Ōmi Province" (*Ōmi hakkei no uchi*: *Karasaki yau*). Ōban size. Published by Eisendō, *ca.* 1835–39.
There are two versions of this print, one in black, the other in indigo. The series was put on sale as "a series of pictures done in muted colors in the style of the old monochromes," and so it has generally been held that the print in which the old pine tree is done entirely in black ink, the one commonly illustrated, was the print offered for sale to the general public. In either print a great stillness envelops the ancient pine of Karasaki as it soars upward into the night, rendered dim in a splashing downpour. Judging from the absence of any damage to the blocks, the indigo print would seem to have been a comparatively early experiment by Hiroshige. While the picture is rather lacking in a feeling for night rain, one is yet loath to set aside these limpid indigo tones in favor of the version in black.

15. *Karuizawa*, from the series "Sixty-nine Stages of the Kisokaidō" (*Kisokaidō rokujū-kyū tsugi no uchi*: *Karuizawa*). Ōban size. Published by Kinjudō, *ca.* 1835–42.
The sun has gone down in this scene, apparently a road near the already darkened way station—bonfires are still burning red, and travelers are finding lights for their pipes. Apart from the green of the ground, the mountain, the trees, and the line of houses are all drawn in shades of black ink. Wrapped in the darkness of the night, only the men and the horse in the foreground are rendered in color. The places where the light is caught are purposely colored more brightly—where the tree is lighted by the fire and where the man on horseback is illumined by the paper lantern—a technique rare for Hiroshige's day and one of the finer points of this print. Variations in brightness have also been added to the smoke of the fire, and on the paper lantern can be seen the characters of the publisher's name.

16. *Mochizuki*, from the series "Sixty-nine Stages of the Kisokaidō" (*Kisokaidō rokujū-kyū tsugi no uchi*: *Mochizuki*). Ōban size. Published by Kinjudō, *ca.* 1835–42.
Following an oblique line, the road continues along a gentle slope, disappearing beyond the pass at the left. The line of roots and mounds at the base of the row of pines, as well as the line of people walking along the road, converge at the top of the pass, creating a profound sense of depth. The unnaturalness of the rudimentary perspective techniques of the *uki-e*, derived from Western perspective, has disappeared, and we have here a realistic portrayal based on nature. From the top of the pass and off to the left, the tops of the line of pines become progressively lower, and we glimpse beyond the pass the emerging upper half of a traveler. Hiroshige's realism is seen in his attempt to make us feel the road continuing on beyond the pass. To the right is a deep valley from which mountains and trees float upward.

17. *Mieji*, from the series "Sixty-nine Stages of the Kisokaidō" (*Kisokaidō rokujū-kyū tsugi no uchi*: *Mieji*). Ōban size. Published by Kinjudō, *ca.* 1835–42.
The western sky is red, and the forest in the distance and shadows here and there are darkening, leaving only the sky bright and clear, with the water in the paddies shining whitely as it reflects the sky. This print marvelously expresses that moment of beauty when the sun has just set. A traveler who has just descended the sloping road appears to be asking directions to this evening's way station. Hiroshige invariably chooses early morning, evening, or late night for his settings, introducing people appropriate to the place portrayed and gracing the scene with a tasteful air. The red camellias are particularly lovely. In this print, as in others, Hiroshige adds emphasis to the individual elements by means of a compositional

structure that places simple description in the left half against a right half filled with flora and people.

18. *Tarui*, from the series "Sixty-nine Stages of the Kisokaidō" (*Kisokaidō rokujū-kyū tsugi no uchi: Tarui*). Ōban size. Published by Kinjudō, *ca.* 1835–42.
On left and right, people of the way station crouch down as they emerge to greet guests. A man carrying an umbrella and walking with his body slightly bent serves as a guide to the two files of a procession, at the rear of which a palanquin is visible. This is the solemn entry into a way station by a great feudal lord. And, rare for Hiroshige, the scene is presented ceremoniously in a left-right symmetry, with the trees that line the road set at center stage. The men at the head of the incoming columns have their feet buried to the ankles because the rain has left the road a mire, a feature that illustrates Hiroshige's observation of detail. Interesting to note are the woodblock prints of beautiful women, Mount Fuji, and landscapes of Edo inside the teahouse on the right.

19. *Seba*, from the series "Sixty-nine Stages of the Kisokaidō" (*Kisokaidō rokujū-kyū tsugi no uchi: Seba*). Ōban size. Published by Kinjudō, *ca.* 1835–42.
In the print *Autumn Moon over Tamagawa* (pl. 12) we have a clear night sky, the branches of the willow gently swayed by a breeze blowing along the riverbed. *Seba* depicts the same sort of riverbank, but what a difference there is! The wind blowing across open fields has a certain harshness. Even the reeds at the water's edge rustle noisily, and there is something eerie in the redness of the clouds. And yet nature is not so well ordered as this. Hiroshige has eliminated unnecessary elements from the profusion of nature, and he has created a new and structured order, showing a fine sensitivity for structural forms.

20. *New Year's Market at Asakusa Temple*, from the series "Famous Places of the Eastern Capital" (*Tōto meisho: Asakusa Kinryūzan toshi no ichi*). Ōban size. Published by Sanoki, *ca.* 1842.
21. *Crowds in the Theater Quarter*, from the series "Famous Places of the Eastern Capital" (*Tōto meisho: Shibai-chō han'ei no zu*). Ōban size. Published by Yamamoto, *ca.* 1845. (See pl. 26 for another print from this series.)
In the Asakusa Temple print, market stalls fill the temple grounds, and between them is a sea of snow-piled umbrellas. The Hall of Kannon to the left is also filled with crowds of people, and the whole of the sky is full of continuously falling snow. All of this crowding together of various elements creates this print's appeal. Even when he pictures the crush of crowds in the market place, as here, with red and white beautifully contrasted, it is characteristic of Hiroshige that the overall mood is virtually always one of quietness. *Crowds in the Theater Quarter* is thus rather remarkable in that it depicts a scene of tumultuous activity. Also unusual here for Hiroshige is the strong sense of *uki-e* perspective, which was derived from Japanese studies of Western art. It should be noted that these two prints are from different series, though the titles are identical.

22. *Shower on Nihonbashi*, from the series "Famous Places of the Eastern Capital" (*Tōto meisho: Nihonbashi no hakuu*). Ōban size. Published by Kikakudō, *ca.* 1834–35. (See pl. 23 for another print from this series.)
A sprinkling of rain falls on Nihonbashi, Edo's most famous bridge and the point from which all distances were measured in Japan. On the far bank of the river stand lines of solidly built white-walled storehouses, and in the distance can be seen Edo Castle. This print sets as its mark a solid pictorial structuring through a combination of such stable features as stone embankments, a castle, earth-walled storehouses, and the bridge. The scene is one that conveys severe strength, a clear-cut and self-confident beauty. While the wonderful snow scene at night in *Kanbara* (pl. 5) has a beauty that can be called lyrical, here there is a new poetry of structural forms. Of the twenty-nine prints of this series, *Shower on Nihonbashi* is conspicuous for its excellence.

23. *Atop Mount Atago in the Shiba District*, from the series "Famous Places of the Eastern Capital" (*Tōto meisho: Shiba Atago sanjō no zu*). Ōban size. Published by Kikakudō, *ca.* 1834–35. (See pl. 22 for another print from this series.)
24. *Cherry Blossoms at Their Peak along Sumida River*, from the series "Famous Places of the Eastern Capital" (*Tōto meisho: Sumida-*

gawa hanazakari). Ōban size. Published by Kawashō, *ca.* 1840–42.
25. *Evening Afterglow at Imado*, from the series "Famous Places within the Eastern Capital: Eight Views of Sumida River" (*Tōto meisho no uchi: Sumida hakkei: Imado yūshō*). Ōban size. Published by Sanoki, *ca.* 1840–42.
26. *Shinobazu Lotus Pond at Ueno*, from the series "Famous Places of the Eastern Capital" (*Tōto meisho: Ueno Shinobazu hasuike*). Ōban size. Published by Yamamoto, *ca.* 1845. (See pl. 21 for another print from this series.)
As Hiroshige gained in popularity, he painted an extremely large number of landscapes of famous places in Edo at the request of various publishers. There are more than fifty varieties among the series alone, each series running from ten to thirty prints, so perhaps it is understandable that many of the series have identical titles. If the single-sheet prints are added to the series, the total amounts to a vast quantity. Note that the print in plate 25, one of bright color tones, eschews the use of black ink outlining.

27. *Bush Clover and Frog*, from the series of prints for nonfolding fans "Flowers in the Four Seasons" (*Shiki no hana zukushi: Hagi to kaeru*). Published by Ibasen, *ca.* 1843–47.
28. *Snowy Heron amid Bulrushes* (*Futoi ni shirasagi*). Chū-tanzaku size. Published by Kawashō, *ca.* 1834. Riccar Art Museum, Tokyo.
29. *Cherry Blossoms and Small Bird* (*Sakura ni shōkin*). Ōtanzaku size. Publisher unknown, *ca.* 1832. Riccar Art Museum, Tokyo.
Apart from the works of his last years, a great many of Hiroshige's landscapes are characterized by black ink and indigo tonality, other colors being few in number and limited in pictorial role. The bird and flower prints, however, show Hiroshige's paintings rich in bright coloration. The snowy heron print employs no black ink outlining, the surrounding color producing the soft fluffiness of the feathers. Moreover, uninked embossing for the feathers, not seen in the reproduction, enhances so much more the beauty of the white.

30–33. *Spring: Cherry Blossoms at Gotenyama; Summer: Moon at Ryōgoku Bridge; Autumn: Maples at Kaianji Temple; Winter: Snow along Sumida River*: the series "Famous Places of Edo in the Four Seasons" (*Shiki Edo meisho: Haru: Gotenyama no hana; Natsu: Ryōgoku no tsuki; Aki: Kaianji no kōfū; Fuyu: Sumidagawa no yuki*). Chū-tanzaku size. Published by Kawashō, *ca.* 1834.
This series is one of Hiroshige's earliest in the *tanzaku* format, each print of which is a meticulous work richly endowed with Hiroshige's lyricism. In the *Spring* print, the mildness of a windless spring day is skillfully expressed through a compositional structure of horizontal and perpendicular lines, such as the horizon line running across the center of the print and the upright signposts and ship masts. The gentle rays of the spring sun are felt in the quiet pink of the cherry blossoms and the cool green of the grassy slope. Gotenyama, a hill facing the sea to the west of the Shinagawa way station on the Tōkaidō, was well known for the loveliness of its cherry trees in bloom.
The vicinity of Ryōgoku Bridge, which spanned Edo's Sumida River, was a favorite night spot for people seeking relief from the summer heat. In the *Summer* print is pictured the bridge and the river under a full moon. There are two or three roofed boats in the distance, and in the foreground a melon peddler, a familiar figure who wound his way among the roofed boats plying his trade. It is early evening, when there are as yet few people on the river—a moment of tranquility masterfully captured.
Kaianji Temple, which was located on a hill adjacent to Gotenyama, commanded an excellent view of the sea, and in the autumn the beautiful coloring of the maple trees there attracted people from Edo who enjoyed strolling. Is it possible that the figure on the left in the *Autumn* print, dressed in the manner of a *haikai* poet, is actually Hiroshige himself?
Ceaselessly falling snow, a man poling a raft, an embankment and randomly driven piles. . . . *Winter* is a simple composition, and yet the entire scene is dominated by the deep tranquility characteristic of Hiroshige. This is Hiroshige's own distinctive world, a world created in indigo and black. The snowflakes filling the composition—white crystals of snow against backgrounds of varying colors—produce a vivid decorative effect.

34. *Thriving Merchants in Ongyoku-machi* (*Ongyoku-machi hanka no shōnin*; top). Print for nonfolding fan. Published by Ibasen, *ca.* 1852.
35. *The Bon Dance*, from the series "A Compendium of Ancient

Dances'' (*Kodai odori zukushi*: *Bon odori*; bottom). Print for non-folding fan. Published by Ibakyū, *ca.* 1843–47.

What is "A Compendium of Ancient Dances," and how many prints were there originally? Was there a model upon which Hiroshige based this print, or is it his own creation? We simply cannot tell. The people who appear in Hiroshige's landscape prints are usually skillfully captured, in form and pose, by simple strokes of the brush, and have about them a certain charm. In *The Bon Dance*, too, Hiroshige has taken pleasure in depicting the old and the young, men and women, in humorous poses. In *Thriving Merchants in Ongyoku-machi* we have a caricature in which both merchants and customers are gotten up like performing artists.

36. *Night Scene at Saruwaka-chō*, from the series "Famous Places in Edo: A Hundred Views" (*Meisho Edo hyakkei*: *Saruwaka-chō yoru no kei*). *Ōban* size. Published by Uoei, 1856–59.

This series, a work of Hiroshige's last years, consists of twenty-eight prints, with an additional one by Hiroshige II; of those said to be by Hiroshige, however, three are suspected of being forgeries. The print here depicts crowds of people in moonlit Saruwaka-chō, the theatrical quarter of Edo, but the scene is one of absolute quiet, the figures unmoving. Whether he depicts people enjoying the cherry blossoms at Gotenyama, or the commotion of a fireworks display at Ryōgoku Bridge, Hiroshige invariably removes himself a step from the excitement, quietly painting the scene from a distance. The print illustrated here is from the first printing. In later printings, the position of the moon is lower, and the shading in black seen under the moon has been eliminated, as has the black wash under the eaves of the buildings. Of particular note are the shadows of the people on the bright surface of the ground, a stylistic innovation that adds a certain freshness to the scene.

37. *Evening Squall on Great Bridge in Atake*, from the series "Famous Places in Edo: A Hundred Views" (*Meisho Edo hyakkei*: *Ōhashi Atake no yūdachi*). *Ōban* size. Published by Uoei, 1856–59.

The surface of the river shining white with spray from the downpour, Atake-chō appearing dimly through the rain in a faint black wash, people hurrying across the bridge. . . . Hiroshige's skilled representation of rainy scenes remains excellent, even in a work such as this done in his last years. This is the masterpiece of a series which has a large number of prints using dark colors. The shading of the surface of the water seen at upper left and lower right, as well as that of the top of the bridge, were eliminated in later printings. There is also a variant printing in which two more boats have been added in ink wash. The scene is tightened by the black clouds that cover the upper extreme of the picture.

Bibliography

Akiyama, Terukazu. *Japanese Painting*. New York: Rizzoli International Publications, 1978.

Chibbett, David. *The History of Japanese Printing and Book Illustration*. Tokyo and New York: Kodansha International, 1977.

Hillier, J. *Japanese Color Prints*. New York: Dutton, 1972.

———. *The Japanese Print: A New Approach*. Rutland, Vt. and Tokyo: Tuttle, 1975.

Keene, Donald. *World within Walls*. New York: Harper and Row, 1976.

Kobayashi, Tadashi. *Ukiyo-e*. Tokyo and New York: Kodansha International, 1982.

Lane, Richard. *Images from the Floating World: The Japanese Print*. New York: Putnam, 1978.

Lee, Sherman E. *Japanese Decorative Style*. New York: Harper and Row, 1972.

———. *A History of Far Eastern Art*. Rev. ed. Englewood Cliffs, N.J.: Prentice-Hall, 1974.

Michener, James. *The Floating World*. New York: Random House, 1954.

———. *Japanese Prints: From the Early Masters to the Modern*. Rutland, Vt. and Tokyo: Tuttle, 1963.

Narazaki, Muneshige. *The Japanese Print: Its Evolution and Essence*. Tokyo and New York: Kodansha International, 1966.

———. *Hiroshige: Famous Views*. Masterworks of Ukiyo-e. Tokyo and New York: Kodansha International, 1968.

———. *Hiroshige: The 53 Stations of the Tōkaidō*. Masterworks of Ukiyo-e. Tokyo and New York: Kodansha International, 1969.

———. *Studies in Nature: Hokusai-Hiroshige*. Masterworks of Ukiyo-e. Tokyo and New York: Kodansha International, 1970.

Noma, Seiroku. *The Arts of Japan*. 2 vols. Standard ed. Tokyo and New York: Kodansha International, 1966.

Paine, R. T., and Soper, Alexander. *The Art and Architecture of Japan*. Rev. ed. New York: Penguin, 1975.

Society for the Study of Japonisme, ed. *Japonisme in Art: An International Symposium*. Tokyo and New York: Committee for the Year 2001 and Kodansha International, 1980.

Swann, Peter. *A Concise History of Japanese Art*. Rev. ed. of *An Introduction to the Arts of Japan*, 1958. Tokyo and New York: Kodansha International, 1979.

Takahashi, Seiichiro. *Traditional Woodblock Prints of Japan*. Tokyo and New York: Weatherhill, 1972.

Tokuriki, Tomikichiro. *Tokaido: Hiroshige*. Elmsford, N.Y.: Japan Publications, 1976.

Warner, Langdon. *The Enduring Art of Japan*. New York: Grove Press, 1958.

"Fifty-three Stages of the Tōkaidō"

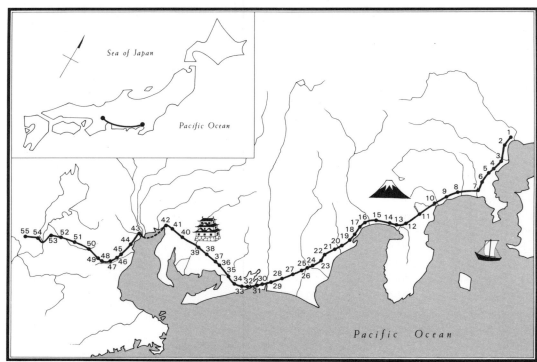

1 Nihonbashi	20 Fuchū	39 Okazaki
2 Shinagawa	21 Mariko	40 Chiryū
3 Kawasaki	22 Okabe	41 Narumi
4 Kanagawa	23 Fujieda	42 Miya
5 Hodogaya	24 Shimada	43 Kuwana
6 Totsuka	25 Kanaya	44 Yokkaichi
7 Fujisawa	26 Nissaka	45 Ishiyakushi
8 Hiratsuka	27 Kakegawa	46 Shōno
9 Ōiso	28 Fukuroi	47 Kameyama
10 Odawara	29 Mitsuke	48 Seki
11 Hakone	30 Hamamatsu	49 Sakanoshita
12 Mishima	31 Maisaka	50 Tsuchiyama
13 Numazu	32 Arai	51 Minakuchi
14 Hara	33 Shirasuka	52 Ishibe
15 Yoshiwara	34 Futakawa	53 Kusatsu
16 Kanbara	35 Yoshida	54 Ōtsu
17 Yui	36 Goyu	55 Kyoto
18 Okitsu	37 Akasaka	
19 Ejiri	38 Fujikawa	

Note: Hiroshige's "Fifty-three Stages of the Tōkaidō" is composed of fifty-five prints, one each on the way stations and the two terminuses. The complete set is illustrated here to give the reader an idea of the scope of the series. The print numbers are correlated with the map showing the route of the Tōkaidō. The prints reproduced here, kindly provided by the Adachi Institute of Woodcut Prints, are facsimiles made from hand-carved woodblocks and using the same materials as the originals.

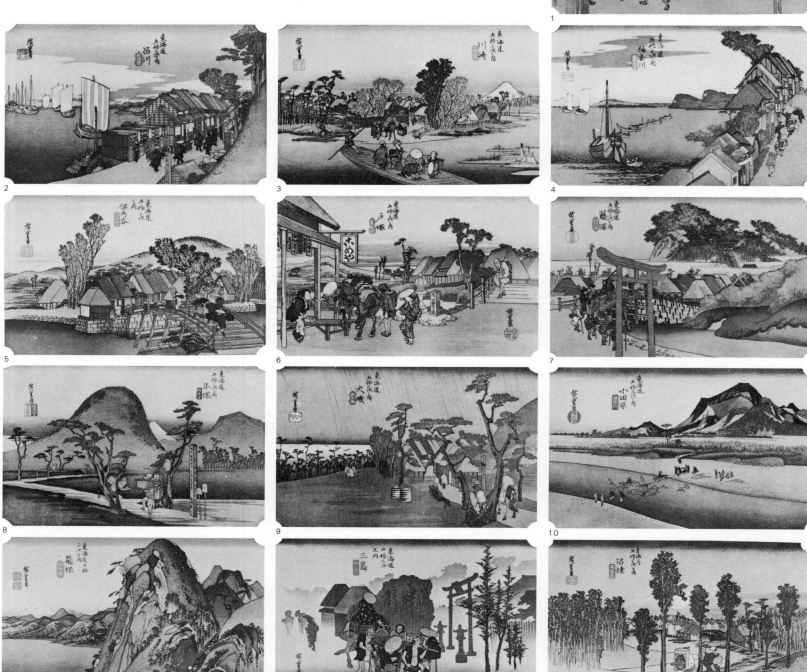

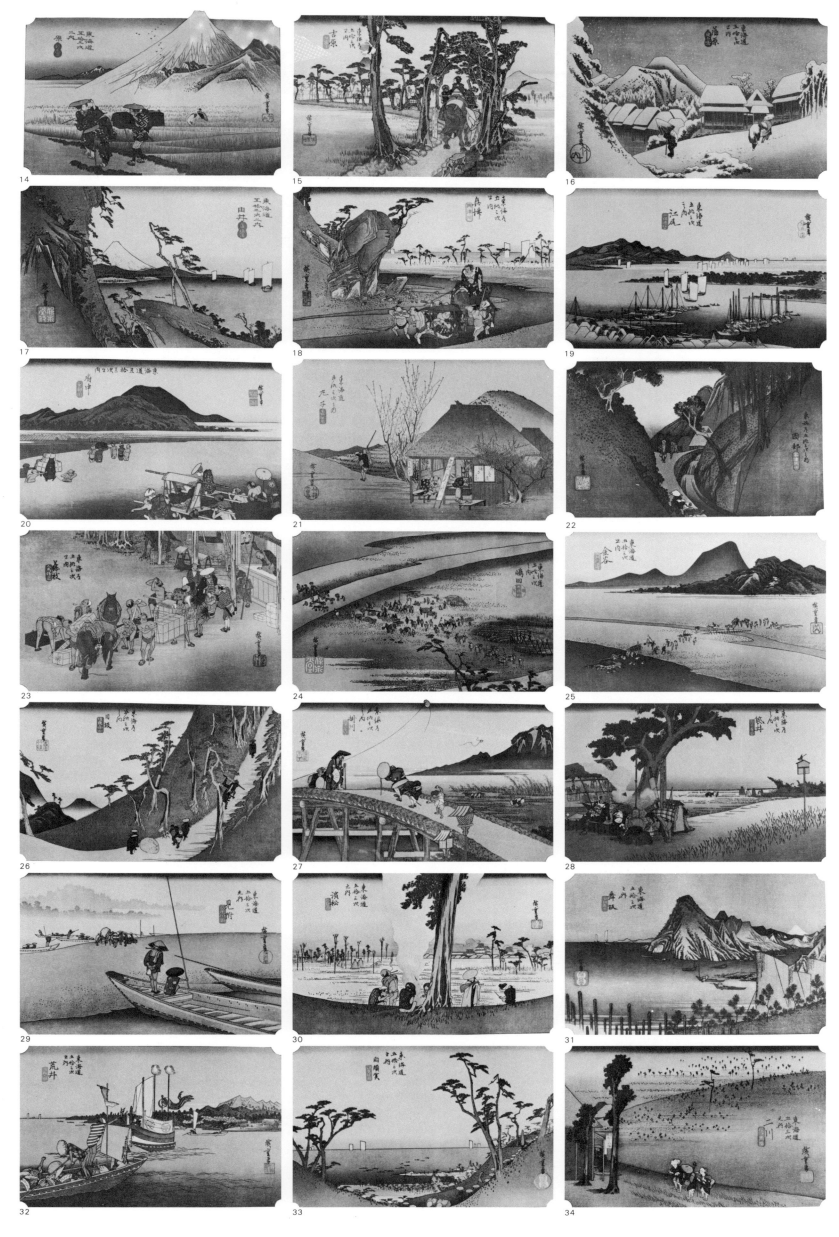

14

15

16

17

18

19

20

21

22

23

24

25

26

27

28

29

30

31

32

33

34

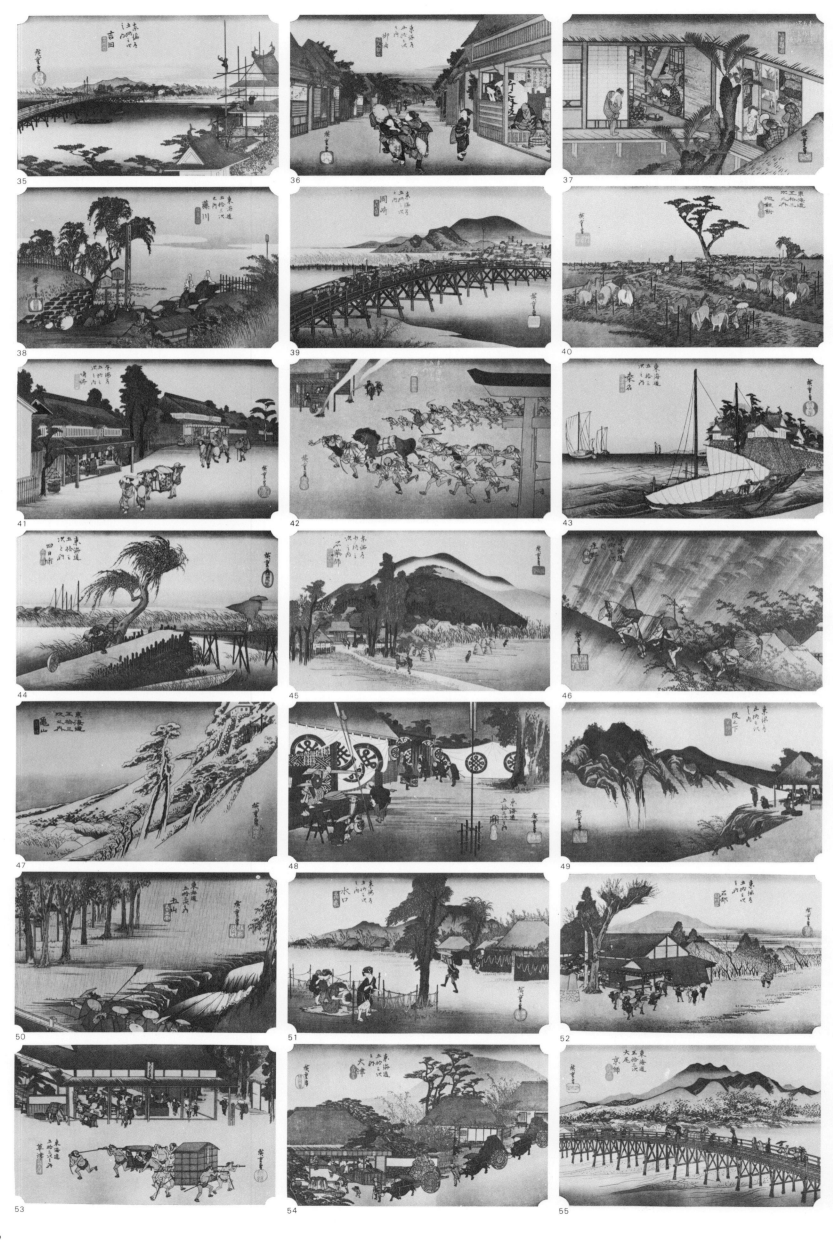

Italian Text

1. *Takanawa sotto una luna settembrina*, dalla serie "Luoghi famosi della Capitale Orientale" (*Tōto meisho: Takanawa no meigetsu*). Formato *ōban*. Edita da Kawaguchi Shōzō. 1831 ca.
Questa serie consiste di dieci stampe, ognuna con l'iscrizione "Quadro di Ichiryūsai Hiroshige" e ognuna montata su cornice. In *Takanawa sotto una luna settembrina* il gruppo delle oche dipinte in grande al centro della scena, così come in *Ryōgoku sotto una luna serale* (tav. 2) le travi portanti del ponte presentate in completo primo piano, mostrano l'audacia di composizione che frequentemente è presente in questa serie. Si pensa che la tecnica sia dovuta all'influenza di Hokusai. Tuttavia, piuttosto che cercare di sorprendere l'osservatore, secondo lo stile di Hokusai, Hiroshige sembra aspirare a dipingere la grandiosità di spazi aperti attraverso il contrasto tra il primo piano e il panorama retrostante. Questa serie rappresenta il primo tentativo di Hiroshige nel campo delle stampe di tipo paesaggistico in formato *ōban* e mostra un fresco stile giovane. Attraverso questo tentativo, Hiroshige scoprì nei paesaggi il genere più congeniale al suo temperamento.

2. *Ryōgoku sotto una luna serale*, dalla serie "Luoghi famosi della Capitale Orientale" (*Tōto meisho: Ryōgoku no yoizuki*). Formato *ōban*. Edita da Kawaguchi Shōzō. 1831 ca.
Questa stampa è una di due varianti. In quella solitamente riprodotta, le travi incrociate di sostegno del ponte e le case sulla costa lontana sono stampate in ocra. Ho preferito includere qui la versione meno conosciuta, stampata principalmente in indaco (*aizuri*), il colore di altre stampe in questa serie. Un gruppo di nuvole rosse basse sull'orizzonte nella stampa in ocra, in questa variante è stato totalmente eliminato. Molti hanno messo in rilievo l'influenza di Hiroshige sull'artista americano Whistler; questa stampa ricorda uno dei quadri di Whistler: *Il vecchio ponte di Battersea* (tav. 10).

3. *Mariko*, dalla serie "Cinquantatrè stazioni della Tōkaidō" (*Tōkaidō gojū-san tsugi no uchi: Mariko*). Formato *ōban*. Edita da Hōeidō. 1832–34.
Qui Hiroshige ha rappresentato, sullo sfondo di un paesaggio pastorale, un negozio dove si vende il famoso brodo di Mariko, fatto di patate dolci grattugiate—l'insegna appesa davanti alla bottega reclamizza il prodotto. L'idea della scena deriva forse dalla storia dei comici itineranti Yaji e Kita nel racconto *Andando a piedi lungo la Tōkaidō* e dall'*haiku* di Bashō:
> Giovani foglie di susino
> E alla stazione di Mariko
> Un brodo di patate dolci grattugiate.

La rossa gradazione del cielo e il fresco verde abilmente riprodotto ai piedi della montagna danno la sensazione di quella qualità vivificatrice propria del principio della primavera, quel tocco di stagione che Hiroshige sempre dà ai suoi paesaggi. Nella prima edizione erano stati usati caratteri differenti per il nome Mariko scritto in alto a sinistra; tuttavia le tirature successive non mostrano differenze sostanziali rispetto all'originale.

4. *Numazu*, dalla serie "Cinquantatrè stazioni della Tōkaidō." (*Tōkaidō gojū-san tsugi no uchi: Numazu*). Formato *ōban*. Edita da Hōeidō. 1832–34.
Di notte, lungo la strada verso la stazione, camminano un genitore e un bambino in pellegrinaggio, così come un uomo che porta sulla schiena una grande maschera del leggendario dio Sarudahiko, per una visita al santuario di Kinpira. La strada curva e porta verso sinistra. Davanti camminano altri pellegrini con le teste abbassate, mentre il ponte dirige il nostro sguardo oltre la linea delle case della stazione. Noi, gli osservatori, camminiamo insieme con i pellegrini, proviamo con loro il sentimento della distanza, poiché la composizione stessa dà il senso della profondità. Sopra la linea delle case una grande luna piena sta iniziando la sua ascesa. Un tono indefinibile raggiunto esclusivamente con l'uso di inchiostri neri e blu rende bene il buio della notte e il chiarore dell'atmosfera lunare. La superficie dell'acqua è anch'essa chiara, effetto dovuto forse al riflesso della luna; l'insieme è un quieto, solitario paesaggio di via.

5. *Kanbara*, dalla serie "Cinquantatrè stazioni della Tōkaidō. (*Tōkaidō gojū-san tsugi no uchi: Kanbara*). Formato *ōban*. Edita da Hōeidō; 1832–34.
Esistono due versioni di questa stampa. Una ha, nella parte superiore, una striscia di inchiostro scuro che si sfuma nel grigio tenue del cielo chiaro sul fondo; l'altra, qui riprodotta, è completamente il contrario: il cielo che tocca le case e le montagne è stampato in inchiostro nero e si sfuma, in alto, in toni più chiari. La prima viene considerata prima tiratura, ma si riproduce qui la seconda perché più significativamente dà l'idea della profondità, della calma notturna e della bellezza del bianco e nero. La solitudine della stazione coperta di neve, addormentata nelle profondità della notte, e le figure che prestano umano interesse alla scena, riscaldano tutte il cuore dell'osservatore.

6. *Shōno*, dalla serie "Cinquantatrè stazioni della Tōkaidō" (*Tōkaidō gojū-san tsugi no uchi: Shōno*). Formato *ōban*. Edita da Hōeidō. 1832–34, Tokyo, Museo Nazionale.
La scena, insolita per Hiroshige, raffigura un moto violento. La ferocia della pioggia è riprodotta nel suo fitto scrosciare attraverso l'acuto angolo di incidenza, e con aree che si alternano di rovesci ora più ora meno potenti. Nel movimento degli alberi si è stabilito un certo ordine. Il boschetto sullo sfondo, che si curva con un tremito sotto un'improvvisa raffica di vento, si muove da destra a sinistra in balenii di grigio, dando una sensazione di potenza nel movimento. Hiroshige ha delineato in modo magistrale la turbolenza del rovescio attraverso un abilissimo ritratto della gente che fugge disordinatamente e il tumulto dei dintorni prodotto da raffiche improvvise di pioggia. Ha aggiunto un tocco di stagione attraverso il colore chiaro dell'erba sul sentiero che sale.

7. *Fukuroi*, dalla serie "Cinquantatrè stazioni della Tōkaidō" (*Tōkaidō gojū-san tsugi no uchi: Fukuroi*). Formato *ōban*. Edita da Hōeidō, 1832–34, Tokyo, Riccar Art Museum.
Sulla strada, a poca distanza dalla stazione, è ritratta una rustica rivendita di té, riparata da una tettoia di giunco. Nella metà sinistra della stampa Hiroshige ha incluso in primo piano il chiosco del té, la gente e un albero; nella metà destra ha costruito un grande spazio aperto. La composizione è una di quelle che Hiroshige amava riprodurre con il contrasto tra sinistra e destra, tra sfondo e primo

piano, tra scarsità e densità degli oggetti ritratti. I viaggiatori si fermano per fumare mentre la padrona del chiosco rimesta il fuoco cercando di evitare il fumo. Si può dire che la scena abbia luogo lungo una strada qualunque e si può notare l'abilità con cui sono riprodotti atteggiamento e aspetto dei vari personaggi. Nella metà destra, piuttosto semplice, della scena, l'uccellino sull'insegna è collocato in modo perfetto.

8. *Mitsuke*, dalla serie "Cinquantatrè stazioni della Tōkaidō" (*Tōkaidō gojū-san tsugi no uchi: Mitsuke*). Formato ōban. Edita da Hōeidō. 1832–34.
Mitsuke era una stazione a est del fiume Tenryū. La gente che viaggiava dalla regione di Kyōto-Ōsaka, la cosiddetta Kamigata, a Edo, aveva da qui la prima veduta del Monte Fuji, e così si dice che il luogo sia stato chiamato "Mitsuke" cioè "Che attrae l'attenzione". La scena raffigura il battello che attraversa il fiume Tenryū sotto una fitta pioggerella. I viaggiatori che aspettano sul pontile sono avvolti in mantelli da pioggia e anche la soma del cavallo è coperta per ripararla dall'acqua. I barcaioli in primo piano, con le spalle rivolte all'osservatore, hanno un aspetto pieno di quella grazia caratteristica dei personaggi di Hiroshige. Sebbene si tratti di un paesaggio, il ruolo giocato dalle figure umane in primo piano e a media distanza è eccezionale; senza di esse il quadro perderebbe tutta la sua vitalità.

9. *Il fiume Yodo*, dalla serie "Luoghi famosi di Kyōto" (*Kyōto meisho no uchi: Yodogawa*). Formato ōban. Edita da Eisendō, 1835 ca.
La gente sulla barca è stata ritratta in un modo estremamente interessante: una donna culla un bambino piccolissimo, un uomo si appoggia su un gomito e sonnecchia, un pellegrino vestito di bianco si scuote di dosso la sonnolenza in vista del santuario del Monte Kinpira. C'è varietà di movimento nei barcaioli del battello più grande, mentre la barca più piccola, ad esso accostata, che vende cibo, è quasi miniaturizzata. Il battello detto "30 koku" (circa 150 stai occidentali) riprodotto vigorosamente nei suoi dettagli di costruzione, chiaramente delineati, nonostante i moltissimi passeggeri a bordo naviga in modo stabile. La gente sulla barca, il suo atteggiamento e le sue caratteristiche, sembrerebbero essere il centro dell'interesse, ma la traversata fluviale è abilmente correlata alla natura circostante attraverso il lucido indaco del cielo e della superficie dell'acqua con le loro ombre, e attraverso la lucentezza di una luna piena.

10. *Ciliegi in piena fioritura ad Arashiyama*, dalla serie "Luogi famosi di Kyōto" (*Kyōto meisho no uchi: Arashiyama manka*). Formato ōban. Edita da Eisendō, 1835 ca.
Gli alberi sulla riva distante, il verde lungo la sponda dell'acqua, anche il fumo prodotto dal fuoco sulla zattera, tutto è inclinato verso destra, tutto rispettando l'armonia del movimento da sinistra a destra della composizione. La scena è di una grande pace, nella quale una zattera si muove dolcemente nella corrente tra una cascata di ciliegi in fiore. La sponda più lontana è indicata solo con un leggero tratto di inchiostro nero; solo i ciliegi sono chiari, il loro colore richiama la chiarezza dell'indaco sulla superficie dell'acqua. E'una nuova forma di composizione nella quale il fiume è riprodotto ampiamente mentre la sponda lontana con i ciliegi in fiore è ritratta obliquamente. Sebbene un certo numero di stampe in questa serie si basi su illustrazioni pubblicate in opere precedenti come *Famosi luoghi illustrati di Miyako [Kyōto]*, quelle qui presentate sono di altissima qualità.

11–12. *Ritorno in vela a Gyōtoku; Luna autunnale su Tamagawa*, dalla serie "Otto vedute dei dintorni di Edo" (*Edo kinkō hakkei no uchi: Gyōtoku kihan; Tamagawa shūgetsu*). Formato ōban. Edite da Kikakudō, 1835–39. Tokyo, Riccar Art Museum.
Le tirature precedenti della serie includevano poesie comiche *kyōka*, come nel caso delle stampe riprodotte qui, e venivano distribuite agli amatori di tale genere poetico. Si determina così una strettissima relazione tra il quadro e le poesie di accompagnamento. Più tardi, tuttavia, si pubblicarono le stampe senza le poesie. In *Ritorno in vela a Gyōtoku*, solo la barca, posta in un angolo in primo piano, mostra un senso di movimento nella tranquillità di una composizione costruita in gran parte da linee verticali e orizzontali. La stampa rappresenta una delle scene più belle tra le otto della serie. Nella prima tiratura di *Luna autunnale sul Tamagawa*, la luna fu stampata in argento. Vedi tav. 13 per la prima tiratura di questa serie.

13. *Neve notturna ad Asukayama*, dalla serie "Otto vedute dei dintorni di Edo" (*Edo kinkō hakkei no uchi: Asukayama no bosetsu*). Formato ōban. Edita da Taihaidō; 1835–39 ca. Ōta Memorial Museum of Art, Tokyo.
La tecnica di questa stampa si basa sulla variazione dei toni di tenue inchiostro nero. A causa delle difficoltà tecniche nel riprodurre le ombre, in questo quadro vi sono piccole differenze che dipendono dal particolare procedimento di tiratura. Il fatto che ogni esemplare abbia a suo modo un tono ben equilibrato è probabilmente da attribuire alla cura meticolosa prodigata per la stampa di questa serie. I caratteri riprodotti sul margine sinistro, "Edita da Taihaidō," apparivano sulla prima tiratura che fu stampata in edizioni di piccolo formato da distribuire agli amici, e che oggi è molto rara. Poiché la caduta della neve continua fu dipinta a pennello su ogni stampa, ne segue che non vi sono due stampe nelle quali la neve sia la stessa. Nella versione che entrò sul mercato non nevica più. Vedi tavv. 11–12 per l'edizione successiva della stessa serie.

14. *Pioggia notturna a Karasaki*, dalla serie "Otto famose vedute della provincia di Ōmi" (*Ōmi hakkei no uchi: Karasaki yau*). Formato ōban. Edita da Eisendō; 1835–39 ca.
Esistono due versioni di questa stampa, una in nero e una in indaco. La serie fu messa in vendita come "serie di quadri a colori smorzati secondo lo stile dei vecchi monocromi," e così si è sempre pensato che la stampa nella quale il vecchio pino è dipinto interamente con inchiostro nero, quella generalmente riprodotta, fosse la stampa messa in vendita al pubblico. In entrambe le stampe una grande quiete avvolge l'antico pino di Karasaki mentre si leva alto nella notte, pallido nel fittissimo diluvio. A giudicare dall'assenza di danni agli stampi, la stampa in indaco sembrerebbe essere stata un esperimento di Hiroshige relativamente anteriore a quella in nero. Sebbene il quadro sia piuttosto carente per quanto riguarda il sentimento della pioggia notturna, si è tuttavia restii a mettere da parte i toni limpidi dell'indaco a favore della versione in nero.

15. *Karuizawa*, dalla serie "Sessantanove stazioni della Kisokaidō" (*Kisokaidō rokujū-kyū tsugi no uchi: Karuizawa*). Formato ōban. Edita da Kinjudō; 1835–42 ca.
In questa scena, apparentemente una strada vicino alla stazione già avvolta nell'oscurità, il sole è tramontato — falò stanno ancora ardendo e viaggiatori trovano fuoco per le loro pipe. A parte il verde del terreno, la montagna, gli alberi e la linea delle case sono tutti rappresentati con ombre di inchiostro nero. Avvolti nel buio della notte, solo gli uomini e il cavallo in primo piano sono a colori. I luoghi dove la luce è concentrata — dove l'albero è illuminato dal fuoco e dove l'uomo sulla sella è illuminato dalla luce della lanterna di carta — sono di proposito resi con colori più chiari. Si tratta di una tecnica insolita per i tempi di Hiroshige ed è una delle peculiarità più importanti di questa stampa. Variazioni di luce sono inoltre state aggiunte al fumo del fuoco, e sulla lanterna di carta si possono leggere i caratteri del nome dell'editore.

16. *Mochizuki*, dalla serie "Sessantanove stazioni della Kisokaidō" (*Kisokaidō rokujū-kyū tsugi no uchi: Mochizuki*). Formato ōban. Edita da Kinjudō; 1835–42 ca.
Seguendo una traiettoria obliqua, la strada continua lungo un lieve pendio e sparisce al di là del valico a sinistra. La fila di radici e di monticelli alla base di quella dei pini, come pure quella della gente che cammina sulla strada, convergono alla sommità del valico, creando così un'impressione di profondità. L'innaturalezza delle tecniche rudimentali di prospettiva dell'*uki-e*, derivate da quelle della prospettiva occidentale, è scomparsa e si ha qui una realistica descrizione di tipo naturalistico. Dalla cima del valico, e più lontano verso sinistra, la linea delle cime dei pini diventa progressivamente più bassa, mentre, al di là del passo, si vede spuntare il busto di un viaggiatore. Il realismo di Hiroshige si vede nel tentativo di farci pensare che la strada continui oltre il valico. A destra c'è una profonda valle sulla quale le montagne e gli alberi sembrano galleggiare.

17. *Mieji*, dalla serie "Sessantanove stazioni della Kisokaidō" (*Kisokaidō rokujū-kyū tsugi no uchi: Mieji*). Formato ōban. Edita da Kinjudō; 1835–42 ca.
Il cielo occidentale è rosso mentre la foresta in lontananza e le ombre qua e là diventano sempre più scure, lasciando solo il cielo risplendente e chiaro, con l'acqua delle risaie che scintilla quando vi si riflette. Questa stampa esprime meravigliosamente il bellissimo momento quando il sole è appena calato. Un viaggiatore che ha appena disceso la strada in pendenza viene mostrato nell'atto di chiedere la via da seguire per questa stazione immersa nella sera. Hiroshige sceglie invariabilmente la mattina presto, la sera o la notte fonda per le sue ambientazioni, introducendo personaggi funzionali al luogo ritratto e ornando la scena di un'aria raffinata. Le camelie rosse sono particolarmente belle. In questa stampa, come in altre, Hiroshige

aggiunge enfasi agli elementi individuali per mezzo di una struttura compositiva che oppone le semplici descrizioni della metà sinistra a una metà destra piena di vegetazione e di gente.

18. *Tarui*, dalla serie "Sessantanove stazioni della Kisokaidō" (*Kisokaidō rokujū-kyū tsugi no uchi: Tarui*). Formato *ōban*. Edita da Kinjudō, 1835–42 ca.
Sulla sinistra e sulla destra, la gente della stazione è mostrata nell'atto di salutare i clienti. Un uomo che porta un ombrello e che cammina leggermente curvo serve come guida alle due ali di una processione in coda alla quale si scorge una portantina. E' la solenne entrata alla stazione di un grande feudatario. E, insolito per Hiroshige, la scena è presentata cerimoniosamente in una simmetria parallela dove gli alberi, che fiancheggiano la strada, sono raffigurati al centro. Gli uomini davanti alle colonne di entrata hanno i piedi sepolti nella melma fino alle caviglie perché la pioggia ha reso fangosa la strada, elemento questo che mostra l'amore di Hiroshige per il dettaglio. Degni di nota sono i *clichés* di stampa delle belle, del Monte Fuji e dei paesaggi di Edo all'interno della casa da té sulla destra.

19. *Seba*, dalla serie "Sessantanove stazioni della Kisokaidō" (*Kisokaidō rokujū-kyū tsugi no uchi: Seba*). Formato *ōban*. Edita da Kinjudō; 1835–42 ca.
Nella stampa *Luna autunnale sul Tamagawa* (tav. 12) i rami del salice sono armoniosamente fatti ondeggiare da un venticello che soffia lungo l'alveo del fiume, sotto un cielo chiaro, ma notturno. In *Seba* è riprodotto lo stesso tipo di riva, ma con che differenza! Il vento che soffia verso i campi aperti ha una indiscutibile asprezza. Anche i giunchi sulla sponda stormiscono rumorosamente; c'è, inoltre, qualcosa di misterioso nel colore rosso delle nuvole. Eppure non vi è nella natura lo stesso ordine che c'è nella stampa. Hiroshige ha eliminato dalla natura gli elementi superflui e ha creato un nuovo ordine che mostra una sottile sensibilità per le forme strutturali.

20. *Mercato di Capodanno al tempio Asakusa*, dalla serie "Luoghi famosi della Capitale Orientale" (*Tōto meisho: Asakusa Kinryūzan toshi no ichi*). Formato *ōban*. Edita da Sanoki; 1842 ca.

21. *Folla nel quartiere del teatro*, dalla serie "Luoghi famosi della Capitale Orientale" (*Tōto meisho: Shibai-chō han'ei no zu*). Formato *ōban*. Edita da Yamamoto; 1845 ca. (Vedi tav. 26 per un'altra stampa di questa serie).
Nella stampa del Tempio Asakusa, bancarelle riempiono i giardini del tempio, e tra queste fluisce un mare di ombrelli coperti di neve. L'Entrata di Kannon a sinistra è stipata di folla, sotto un cielo completamente coperto per la neve che continua a scendere. Tutto l'insieme dei vari elementi crea il fascino di questa stampa. Anche quando raffigura la calca della folla al mercato, come in questo caso, con il contrasto riuscitissimo del bianco e del rosso, Hiroshige mostra come lo stato d'animo che ne deriva sia sempre quello di quiete. *Folla nel quartiere del teatro* è importante per il fatto che, al contrario della stampa precedente, raffigura una scena di tumultuosa attività. Insolito qui, per Hiroshige, è il forte senso della prospettiva *uki-e*, derivante dagli studi giapponesi sull'arte occidentale. Si noti che queste due stampe provengono da due serie differenti, sebbene i titoli siano eguali.

22. *Acquazzone sul Nihonbashi*, dalla serie "Luoghi famosi della Capitale Orientale" (*Tōto meisho: Nihonbashi no hakuu*). Formato *ōban*. Edita da Kikakudō; 1834–35 (Vedi tav. 23 per un'altra stampa di questa serie).
Una spruzzata di pioggia cade sul Nihonbashi, il più famoso ponte di Edo e il punto da cui, in Giappone, venivano misurate tutte le distanze. Sulla riva lontana del fiume vi sono file di magazzini solidamente costruiti e dai muri bianchi, mentre all'orizzonte si vede il castello di Edo. L'aspetto peculiare di questa stampa è una struttura pittorica riconoscibile attraverso una combinazione di forme architettoniche come argini in muratura, un castello, magazzini dai muri di terra e il ponte. La scena è una di quelle che possiedono forza austera e bellezza nettamente definita, sicura di sé. Mentre la meravigliosa scena della neve notturna in *Kanbara* (tav. 5) è di una bellezza che si può definire lirica, qui c'è una poesia nuova di forme strutturali. Delle ventidue stampe di questa serie, *Acquazzone sul Nihonbashi* è notevole per la sua perfezione.

23. *In cima al Monte Atago nel Distretto di Shiba*, dalla serie "Luoghi famosi della Capitale Orientale" (*Tōto meisho: Shiba Atago sanjō no zu*). Formato *ōban*. Edita da Kikakudō; 1834–35 ca. (Vedi tav. 22 per un'altra stampa di questa serie).

24. *Ciliegi in piena fioritura lungo il fiume Sumida*, dalla serie "Luoghi famosi della Capitale Orientale" (*Tōto meisho: Sumida gawa hanakazari*). Formato *ōban*. Edita da Kawashō; 1840–42 ca.

25. *Ultimo bagliore del sole a Imado*, dalla serie "Luoghi famosi della Capitale Orientale: Otto vedute del fiume Sumida" (*Tōto meisho no uchi: Sumida hakkei: Imado yūshō*). Formato *ōban*. Edita da Sanoki; 1840–42 ca.

26. *Shinobazu, il lago dei fiori di loto, a Ueno*, dalla serie "Luoghi famosi della Capitale Orientale" (*Tōto meisho: Ueno Shinobazu hasuike*). Formato *ōban*. Edita da Yamamoto; 1845 ca. (Vedi tav. 21 per un'altra stampa di questa serie.)
Quando Hiroshige raggiunse la popolarità, dipinse un numero grandissimo di paesaggi dei luoghi famosi di Edo, su richiesta di vari editori. Ci sono più di cinquanta varietà in una stessa serie: visto che ogni serie va da dieci a trenta stampe è comprensibile il fatto che molte di esse abbiano lo stesso titolo. Se si aggiungono alle serie le stampe uniche, il totale raggiunge un numero elevato. Si noti che per la stampa della tav. 25, una di quelle a toni chiari, Hiroshige ha evitato di usare l'inchiostro nero per tracciare i contorni.

27. *Trifoglio di macchia e rana*, dalla serie di stampe per ventagli non pieghettati "Fiori nelle quattro stagioni" (*Shiki no hana zukushi: Hagi to kaeru*). Edita da Ibasen; 1843–47 ca.

28. *Candido airone tra giunchi*, (*Futoi ni shirasagi*). Formato *Chū-tanzaku*. Edita da Kawashō; 1834 ca. Tokyo, Riccar Art Museum.
A parte le opere degli ultimi anni, una grande quantità dei paesaggi di Hiroshige sono caratterizzati dalle tonalità prodotte con l'uso di inchiostro nero e dell'indaco, essendo gli altri colori non funzionali alle scene ritratte. Le stampe dell'uccellino e dei fiori mostrano che i quadri di Hiroshige sono ricchi di toni chiari. Nella stampa dell'airone la sofficità del piumaggio viene resa dal colore circostante senza l'uso di inchiostro nero per indicare i contorni. Inoltre il piumaggio è stato riprodotto per mezzo di incisione a secco, tecnica che peraltro non si vede nella stampa e che accresce la bellezza del bianco.

29. *Fiori di ciliegio e uccellino* (*Sakura ni shōkin*). Formato *Ōtanzaku*. Editore sconosciuto; 1832 ca. Tokyo, Riccar Art Museum.

30–33. *Primavera: Fiori di ciliegio a Gotenyama; Estate: Luna sul ponte di Ryōgoku; Autunno: Aceri al tempio Kaianji; Inverno: Neve lungo il fiume Sumida*. La serie "Luoghi famosi di Edo nelle quattro stagioni" (*Shiki Edo meisho; Haru: Gotenyama no hana; Natsu: Ryōgoku no tsuki; Aki: Kaianji no kōfū; Fuyu: Sumidagawa no yuki*). Formato *Chū-tanzaku*. Edite da Kawashō; 1834 ca.
Questa è una delle prime serie in formato *tanzaku*, ogni stampa della quale è un'opera meticolosa estremamente ricca del lirismo proprio a Hiroshige. Nella stampa *Primavera*, la mitezza di un giorno di primavera senza vento è abilmente espressa attraverso una struttura compositiva di linee orizzontali e verticali, come la linea dell'orizzonte che corre verso il centro della stampa, i pali indicatori diritti e gli alberi maestri delle navi. I dolci raggi del sole primaverile si percepiscono nel tenue rosa dei fiori di ciliegio e nel fresco verde del pendio erboso. Gotenyama, una collina di fronte al mare a ovest della stazione di Shinagawa sulla Tōkaidō, era ben conosciuta per la bellezza dei suoi ciliegi in fiore. Il ponte di Ryōgoku, che attraversava il fiume Sumida a Edo, era il luogo di ritrovo serale preferito dalla gente che cercava ristoro dal caldo estivo. Nella stampa *Estate* sono raffigurati il fiume e il ponte sotto una luna piena. Ci sono due o tre giunche in lontananza e in primo piano un venditore ambulante di meloni, figura familiare che si aggirava tra le giunche offrendo insistentemente la sua merce. E' il principio della sera, quando sul fiume c'è ancora poca gente—un momento di tranquillità magistralmente colto. Il tempio di Kaianji, che era situato su una collina adiacente alla Gotenyama, dominava il mare dalla sua posizione, e, in autunno, la meravigliosa colorazione degli aceri richiamava la gente da Edo per una piacevole passeggiata. E' possibile che la figura sulla sinistra della stampa *Autunno*, vestita alla maniera di un compositore di *haikai*, sia realmente lo stesso Hiroshige? Incessantemente cade la neve, un uomo sospinge una zattera, una strada lungo il fiume e cataste di tronchi sospinti irregolarmente. . . . *Inverno* è una composizione semplice, e, ancora, l'intera scena è dominata dalla profonda tranquillità caratteristica di Hiroshige. Questo è il mondo proprio a Hiroshige, un mondo creato in indaco e nero. I fiocchi di neve che completano la composizione—bianchi cristalli contro uno sfondo multicolore—producono un vivo effetto decorativo.

34. *Prosperi mercanti a Ongyoku-machi*, (*Ongyoku-machi hanka no shōnin*; parte superiore). Stampa per ventaglio non pieghettato. Edita da Ibasen; 1852 ca.

35. *La danza Bon*, dalla serie "Un compendio di antiche danze" (*Kodai odori zukushi: Bon odori*; parte inferiore). Stampa per ventaglio non pieghettato. Edita da Ibakyū; 1843-47 ca.
Cos'è il "Compendio di antiche danze" e di quante stampe consisteva originariamente? C'era un modello sul quale Hiroshige basò questa stampa, o si tratta di una sua creazione? Semplicemente non lo si può dire. La gente che appare nelle stampe di tipo paesaggistico di Hiroshige, è di solito abilmente ritratta, nella forma e nell'atteggiamento, con semplici pennellate che mettono in rilievo una certa eleganza. Anche ne *La danza del Bon*, Hiroshige si è concesso il piacere di dipingere il vecchio e il giovane, uomini e donne, in pose divertenti. In *Prosperi mercanti a Ongyoku-machi* la caricatura sta nel fatto che mercanti e clienti sono truccati come attori che stanno recitando.

36. *Scena notturna a Saruwaka-chō*, dalla serie "Luoghi famosi a Edo: Cento vedute" (*Meisho Edo hyakkei: Saruwaka-chō yoru no kei*). Formato ōban. Edita da Uoei; 1856–59.
Questa serie, opera degli ultimi anni di Hiroshige, consiste di ventotto stampe più una fatta da Hiroshige II; di quelle attribuite a Hiroshige, tuttavia, si sospetta che tre siano contraffazioni. La stampa qui riprodotta raffigura torme di gente al Saruwaka-chō, il quartiere dei teatri di Edo, illuminato dalla luna; tuttavia la scena è di assoluta quiete, dovuta all'immobilità delle figure. Sia che dipinga gente che ammira i fiori di ciliegio a Gotenyama, o l'emozione prodotta dalla rappresentazione di fuochi d'artificio sul ponte Ryōgoku, Hiroshige invariabilmente allontana da sé ogni tipo di eccitazione, ritraendo, con calma, la scena da lontano. La stampa qui riprodotta appartiene alla prima tiratura. Nelle tirature successive, la posizione della luna è più bassa, l'ombreggiatura sotto la luna è stata eliminata, come pure il nero sotto le grondaie delle case. Di particolare interesse sono le ombre della gente sulla superficie chiara del terreno: si tratta di un'innovazione stilistica che aggiunge indubitabile freschezza alla scena.

37. *Bufera serale sul grande ponte di Atake*, dalla serie "Luoghi famosi a Edo: Cento vedute" (*Meisho Edo hyakkei: Ōashi Atake no yūdachi*). Formato ōban. Edita da Uoei; 1856–59.
La superficie del fiume che biancheggia di spruzzi per l'acquazzone, Atake-chō che appare indistintamente attraverso la pioggia di un nero tenue, gente che si affretta verso il ponte. La sapiente rappresentazione di scene di pioggia da parte di Hiroshige rimane perfetta anche in un'opera come questa prodotta negli ultimi anni. Questo è il capolavoro di una serie che consiste di un gran numero di stampe nelle quali predominante è l'uso di colori scuri. L'ombra della superficie dell'acqua a sinistra in alto e a destra in basso, così come quella della cima del ponte, furono eliminate nelle tirature successive. Esiste anche una variante dove sono state aggiunte due imbarcazioni in inchiostro nero. La scena è stretta da nuvole nere che coprono l'estremità superiore del quadro.

French Text

1. *Takanawa sous une pleine lune*, appartenant à la série "Lieux célèbres de la capitale orientale" (*Tōto meisho: Takanawa no meigetsu*). Format *Ōban*. Publiée par Kawaguchi Shōzō, vers 1831.
La série consiste en dix estampes, chacune portant l'inscription "Gravure par Ichiryūsai Hiroshigé" et chacune montée sur cadre. *Takanawa sous une pleine lune* représente un troupeau d'oies peint au centre même du tableau. Nous retrouvons ici une audace de la composition que l'on rencontre souvent dans cette série, telles les poutrelles du pont qui sont portées en premier plan dans *Ryōgoku sous une lune crépusculaire* (Planche 2). On pense que cette technique est une influence d'Hokusai. Toutefois, plutôt que d'essayer de surprendre le spectateur, à la manière d'Hokusai, Hiroshigé semble aspirer à peindre la grandeur des espaces ouverts par le truchement du contraste entre le premier plan et l'arrière-plan. Cette série constitue la première tentative d'Hiroshigé dans le domaine des paysages en format ōban et représente un style jeune et frais. Au travers de cette tentative Hiroshigé a trouvé dans les paysages le genre qui convient le mieux à son tempérament.

2. *Ryōgoku sous une lune crépusculaire*, appartenant à la série "Lieux célèbres de la capitale orientale" (*Tōto meisho: Ryōgoku no yoizuki*). Format *Ōban*. Publiée par Kawaguchi Shōzō, vers 1831.
Il existe deux versions de cette estampe. Sur celle qui est le plus souvent reproduite les traverses du pont et les maisons, sur le rivage lointain, sont dé couleur ocre. J'ai préféré inclure ici la version moins connue, celle peinte de couleur indigo (*aizuri*), couleur utilisée sur d'autres gravures de cette même série. Une concentration de nuages rouges, à même l'horizon, sur la version ocre, n'apparaît plus sur la version indigo. Bien des personnes ont fait remarquer l'influence d'Hiroshigé sur l'artiste américain Whistler et il ne fait pas de doute que cette estampe rappelle un des tableaux de Whistler: *Le vieux pont de Battersea* (Fig. 10).

3. *Mariko*, appartenant à la série "Les cinquante trois stations de la Tōkaidō" (*Tōkaidō gojū-san tsugi no uchi: Mariko*). Format *Ōban*. Publiée par Hōeidō, 1832–34.
Ici Hiroshigé a représenté, dans un cadre bucolique, une échoppe où l'on vend le fameux bouillon de Mariko, fait à partir de patates douces râpées – l'enseigne devant la porte fait la réclame du produit. L'idée de cette scène remonte peut-être à l'histoire des comiques itinérants Yaji et Kita dans le conte *A pied le long de la Tōkaidō* et au *haiku* de Bashō:

De tendres feuilles de prunier
Et à la station de Mariko
Un bouillon de patates douces râpées

Les ombres rouges du ciel et le vert frais habilement reproduit au pied de la montagne donnent cette sensation vivifiante de début de printemps, avec ce petit soupçon de saison qu'Hiroshigé sait si bien conférer à ses paysages. Lors de la première édition de l'estampe, des caractères différents avaient été utilisés pour le mot Mariko inscrit en haut à gauche; toutefois, les tirages postérieurs n'accusent pas de différences évidentes par rapport à l'original.

4. *Numazu*, appartenant à la série "Les cinquante trois stations de la Tōkaidō" (*Tōkaidō gojū-san tsugi no uchi: Numazu*). Format *Ōban*. Publiée par Hōeidō, 1832–34.

La nuit, le long de la route qui se dirige vers la station, cheminent trois pèlerins, un père et son enfant et un homme qui porte sur son dos un grand masque du dieu légendaire Sarudahiko, se rendant au sanctuaire de Kinpira. La route tourne puis se dirige vers la gauche. Plus loin d'autres pèlerins avancent, tête basse, tandis que le pont dirige notre regard au-delà de la ligne de maisons de la station. Spectateurs, nous cheminons le long de la route avec les pèlerins et éprouvons avec eux cette sensation de distance que la composition sait si bien rendre. Au-dessus de la ligne des maisons une immense pleine lune entame son ascension. Un ton subtil uniquement obtenu par l'usage d'encres bleues et noires rend très bien la profondeur de la nuit et la clarté de la lune. La surface est également claire, peut-être par suite du reflet de la lune, et le tout constitue un paysage de route solitaire.

5. *Kanbara*, appartenant à la série "Les cinquante trois stations de la Tōkaidō" (*Tōkaidō gojū-san tsugi no uchi: Kanbara*). Format *Ōban*. Publiée par Hōeidō, 1832–34.
Il existe deux versions de cette estampe. Une comporte une bande à l'encre noire, sur le haut de la gravure, qui vient se perdre dans un ciel clair et gris sur le bas; l'autre, qui est reproduite ici, c'est tout l'opposé: le ciel bas, qui touche les maisons et les montagnes, est peint à l'encre noire qui se perd vers le haut en un ciel beaucoup plus clair. La première est considérée comme étant la gravure originale, cependant, la gravure plus récente est illustrée ici parce qu'elle évoque de façon plus intense la profondeur et le calme de la nuit ainsi que la beauté du noir et blanc. La solitude de la station recouverte de neige, endormie dans la profondeur de la nuit et les figures qui donnent un aspect humain à la scène, réchauffent toutes le coeur du spectateur.

6. *Shōno*, appartenant à la série "Les cinquante trois stations de la Tōkaidō" (*Tōkaidō gojū-san tsugi no uchi: Shōno*). Format *Ōban*. Publiée par Hōkeidō, 1832–34. Musée national, Tokyo.
Chose rare chez Hiroshigé, il s'agit ici d'un mouvement violent. La férocité de la pluie est évoquée par sa densité et par son angle de chute, avec alternance d'intensité. Un certain ordre a été établi en ce qui concerne les arbres. Le petit bois à l'arrière, qui fléchit sous une bourrasque de vent soudaine, s'étire de droite à gauche par successions de couleurs grises, ce qui donne une sensation de puissance du mouvement. Hiroshigé a tracé de façon magistrale la turbulence de l'averse en capturant de façon habile la fuite désordonnée des gens et le tumulte des alentours provoqué par cette soudaine trombe d'eau. Il a rajouté un soupçon de saison en introduisant la couleur claire de l'herbe sur le sentier qui monte.

7. *Fukuroi*, appartenant à la série "Les cinquante trois stations de la Tōkaidō" (*Tōkaidō gojū-san tsugi no uchi: Fukuroi*). Format *Ōban*. Publiée par Hōeidō, 1832–34, Tokyo, Musée d'Art Riccar.
Sur la route, à peu de distance de la station, est dépeinte une échoppe de thé rustique, protégée par une palissade de joncs. Sur la moitié gauche de la gravure Hiroshigé a incorporé, au premier plan, le comptoir à thé, les personnes et un arbre; sur la moitié de droite il a laissé un grand blanc. Il s'agit ici d'une des compositions favorites d'Hiroshigé, avec son contraste entre le côté gauche et le côté droit, entre l'arrière-plan et le premier plan, entre le dénuement et l'abondance des objets dépeints. Les voyageurs s'arrêtent pour fumer

tandis que la cantinière attise le feu tout en se protégeant de la fumée. Il s'agit d'une scène commune et on peut relever ici l'habileté avec laquelle sont dépeints le comportement et l'apparence des divers personnages. Sur la moitié de droite de la scène, de façon plutôt simple, le petit oiseau sur l'enseigne est placé de façon parfaite.

8. *Mitsuke*, appartenant à la série "Les cinquante trois stations de la Tōkaidō" (*Tōkaidō gojū-san tsugi no uchi: Mitsuke*). Format *Ōban*. Publiée par Hōeidō, 1832–34.
Mitsuke était une station à l'est de la Tenryū, c'est de là que les voyageurs allant de la Kamigata, région de Kyoto-Osaka, à Edo apercevaient pour la première fois le Mont Fuji et la légende veut que l'emplacement ait reçu le nom de Mitsuke qui en japonais signifie "apercevoir." La scène représente le transbordeur qui traverse la Tenryū sous une bruine. Les voyageurs qui attendent le bateau sur la barre sont enveloppés dans des pèlerines et le fardeau du cheval est également protégé contre le pluie. La vue au-delà de la rivière est obscurcie par la bruine. Les bateliers au premier plan, le dos tourné au spectateur, possèdent cette grâce caractéristique qui est le propre des personnages d'Hiroshigé. Bien qu'il s'agisse ici d'un paysage, le rôle joué par les personnages au premier plan et à mi-distance est exceptionnel, sans eux la gravure perdrait toute sa vitalité.

9. *La Yodo*, appartenant à la série "Lieux célèbres de Kyoto" (*Kyōto meisho no uchi: Yodogawa*). Format *Ōban*. Publiée par Eisendō, vers 1835.
Les personnages qui se trouvent sur le bateau ont été représentés de façon fort intéressante: une femme berce un tout petit enfant, un homme appuyé sur son coude sommeille, un pèlerin vétu de blanc, en visite au sanctuaire de Kinpira, sort de sa somnolence. Il y a toute une variété de mouvements chez les bateliers du bateau plus grand alors que la petite barque qui vend des aliments à son côté est pratiquement miniaturisée. Ce bateau de trente *koku* (150 boisseaux), vioureusement représenté dans les détails de sa construction, bien que transportant un grand nombre de passagers, n'en navigue pas moins de façon très stable. Les passagers du bateau, de par leur comportement et leur particularité, sembleraient constituer le centre focal, cependant la traversée de la rivière est habilement liée à la nature environnante à travers l'indigo clair du ciel, la surface de l'eau avec ses ombres et la clarté d'une pleine lune.

10. *Cerisiers en fleurs à* Arashiyama, appartenant à la série "Lieux célèbres de Kyoto" (*Kyōto meisho no uchi: Arashiyama manka*). Format *Ōban*. Publiée par Eisendō, vers 1835.
Les arbres sur la rive lointaine, le vert le long de l'eau, et même la fumée du feu sur le radeau, penchent tous vers la droite, l'ensemble de la composition se déplaçant de la gauche vers la droite. Il s'agit d'une scène paisible où un radeau redescend lentement les eaux de la rivière entre une cascade de cerisiers en fleurs. La berge la plus éloignée est uniquement représentée par un léger trait à l'encre noire, seuls les cerisiers sont de couleur brillante, celle-ci rappelant la clarté de l'indigo sur la surface de l'eau. C'est une nouvelle forme de composition dans laquelle la rivière est amplement reproduite alors que la berge lointaine avec les cerisiers en fleurs est représentée obliquement. Bien qu'un certain nombre de gravures de cette série soient basées sur des illustrations publiées dans des oeuvres antérieures, tels *"Lieux célèbres de Miyako [Kyoto],"* celles qui sont représentées ici sont d'une qualité exceptionnelle.

11–12. *Retour de voiliers à Gyōtoku*; *Lune d'automne sur Tamagawa*, appartenant à la série "Huit vues des environs d'Edo" (*Edo kinkō hakkei no uchi: Gyōtoku kihan; Tamagawa Shūgetsu*). Format *Ōban*. Publiée par Kikakudō, vers 1835–39. Tokyo, Musée d'Art Riccar.
Les tirages antérieurs de la série comprenaient des poésies comiques *kyōka*, comme dans le cas des deux gravures qui nous concernent, et étaient distribués parmi les amateurs du genre poétique. Il existe donc une relation étroite entre le tableau et le poème qui l'accompagne. Plus tard, cependant, les gravures furent tirées sans poèmes. Dans *Retour de voiliers à Gyōtoku* seul le bateau, placé à un angle au premier plan, exprime une sensation de mouvement au sein de la quiétude d'une composition réalisée en grande partie par des lignes verticales et horizontales. La gravure représente une des scènes les plus belles parmi les huit vues de la série. Sur la première, *Lune d'automne sur Tamagawa*, la lune a été représentée de couleur argent. Se reporter à la planche 13 pour le premier tirage de cette série.

13. *Neige du soir à Asukayama*, appartenant à la série "Huit vues des environs d'Edo (*Edo kinkō hakkei no uchi: Asukayama no bosetsu*). Format

Ōban. Publiée par Taïhaidō, vers 1835–39. Musée d'Art du Monument d'Ōta, Tokyo.
La technique de cette estampe est basée sur la variation des tons d'encre noire légère. Par suite des difficultés techniques à obtenir les ombres, de légères différences apparaissent sur cette gravure, celles-ci étant tributaires du procédé de tirage. Le fait que chaque exemplaire ait, à sa façon, un ton bien équilibré peut probablement être attribué au soin méticuleux accordé à l'impression de cette série. Les caractères imprimés dans la marge de gauche "Publiée par Taihaidō," firent leur apparition sur le premier tirage, qui fut publié selon des éditions de petit format destinées à être distribuées entre amis, très rares de nos jours. Vu que la neige fut peinte au pinceau sur chaque gravure individuelle, il s'ensuit qu'il n'y a pas deux gravures où la neige soit la même. Sur la version destinée à la vente générale, il n'y a pas plus de neige. Se reporter aux Planches 11 et 12 pour les travaux concernant une édition postérieure de la même série.

14. *Pluie nocturne à Karasaki*, appartenant à la série "Huit vues célèbres de la Province d'Ōmi" (*Ōmi hakkei no uchi: Karasaki yau*). Format *Ōban*. Publiée par Eisendō, vers 1835–39.
Il existe deux versions de cette estampe, une en noir et une en indigo. La série fut mise en vente en tant que "série de tableaux aux couleurs atténuées selon le style des anciens monochromes" et ainsi on a toujours pensé que la gravure sur laquelle le vieux pin est représenté uniquement en noir, celle qui est généralement reproduite, était l'estampe mise en vente auprès du grand public. Sur les deux gravures une immense quiétude enveloppe le vieux pin de Karasaki tandis qu'il se dresse tout haut dans la nuit, rendu beaucoup plus terne par la pluie diluvienne. Si l'on en juge par l'absence de dommages causés aux gravures, la gravure en indigo semble représenter une expérience d'Hiroshigé légèrement antérieure à celle en noir. Bien que le tableau soit plutôt pauvre quant à la sensation de pluie nocturne, on hésite toutefois à ignorer les tons limpides de l'indigo en faveur de la version en noir.

15. *Karuizawa*, appartenant à la série "Soixante-neuf stations de la Kisokaidō" (*Kisokaidō rokujū – kyū tsugi no uchi: Karuizawa*). Format *Ōban*. Publiée par Kinjudō, vers 1835–42.
Dans cette scène, apparement une route près de la station déjà enveloppée par l'obscurité, le soleil s'est couché – des feux de joie brûlent encore et des voyageurs attisent leurs pipes. Mis à part le vert du sol, la montagne, les arbres et la ligne des maisons sont tous représentés par des ombres d'encore noire. Enveloppés dans les ténèbres de la nuit, seuls les hommes et les chevaux au premier plan sont représentés en couleur. Les endroits où la lumière se concentre – l'arbre éclairé par le feu et l'homme à cheval illuminé par la lanterne en papier – sont intentionnellement représentés par des couleurs vives. Il s'agit ici d'une technique insolite pour Hiroshigé et d'une des particularités les plus importantes de cette estampe. Des variations d'intensité ont également été ajoutées à la fumée du feu, et sur la lanterne on peut relever le nom de l'éditeur.

16. *Mochizuki*, appartenant à la série "Soixante-neuf stations de la Kisokaidō" (*Kisokaidō rokujū-kyū tsugi no uchi: Mochizauki*). Format *Ōban*. Publiée par Kinjudō, vers 1835–42.
Selon une trajectoire oblique, la route continue le long d'une pente douce, disparaissant au-delà du col sur la gauche. La file de racines et de haies à la base de la rangée de pins, de même que la file de personnes qui marchent le long de la route, convergent au sommet du col, créant ainsi une impression de profondeur. Le caractère recherché des techniques rudimentaires de l'*uki-e*, dérivées de celles de la perspective occidentale, a complètement disparu, et nous avons ici une description réaliste basée sur la nature.

Du sommet du col, et plus loin vers la gauche, la ligne des cimes des pins devient de plus en plus basse et, au-delà du col, on voit apparaître le buste d'un voyageur. Ici le réalisme d'Hiroshigé cherche à nous donner l'impression que la route continue au-delà du col. A droite il y a une vallée profonde au-dessus de laquelle les montagnes et les arbres semblent flotter.

17. *Mieji*, appartenant à la série "Soixante-neuf stations de la Kisokaidō" (*Kisokaidō rokujū-kyū tsugi no uchi: Mieji*). Format *Ōban*. Publiée par Kinjudō, vers 1835–42.
A l'ouest le ciel est rouge tandis que dans le lointain la forêt et les ombres, ci et là, deviennent de plus en plus noires, laissant seul le ciel resplendissant et clair, l'eau des rizières scintillant sous la reflexion du ciel. La gravure capture de façon merveilleuse ce moment de beauté

ultime lorsque le soleil vient juste de disparaître à l'horizon. Un voyageur qui descend la route en pente semble demander son chemin. Hiroshigé choisit invariablement le matin, le soir ou tard la nuit pour ses cadres, introduisant les personnages pertinents dans la scène dépeinte et en ornant la scène d'un air raffiné. Les camélias rouges sont d'une beauté particulière. Sur cette estampe, comme sur beaucoup d'autres, Hiroshigé met l'accent sur les éléments individuels en adoptant une structure de la composition qui fait contraster la simplicité de la description de la moitié gauche à la complexité du côté droit, riche en flore et en personanges.

18. *Tarni*, appartenant à la série "Soixante-neuf stations de la Kisokaidō" (*Kisokaidō rokujū-kyū tsugi no uchi: Tarni*). Format *Ōban*. Publiée par Kinjudō, vers 1835–42.
Sur la gauche et sur la droite, les gens de la station sortent pour accueillir leurs hôtes. Un homme, qui porte un parasol et qui marche légèrement courbé, sert de guide aux deux files d'un cortège, en queue duquel on aperçoit une chaise à porteurs. Il s'agit ici de l'entrée solennelle d'un grand dignitaire féodal dans une station. Et, chose rare pour Hiroshigé, la scène est présentée cérémonieusement selon une symétrie parallèle où les arbres qui longent la route sont représentés au centre. Les personnages qui marchent au devant des colonnes sont enfoncés jusqu'aux chevilles dans la boue que la pluie a laissée sur le chemin, élément qui démontre la passion qu'Hiroshigé avait pour les détails. Il est intéressant de noter les gravures sur bois de belles femmes, du mont Fuji et des paysages d'Edo à l'intérieur de la maison de thé, sur la droite.

19. *Seba*, appartenant à la série "Soixante-neuf stations de la Kisokaidō" (*Kisokaidō rokujū-kyū tsugi no uchi: Seba*). Format *Ōban*. Publiée par Kinjudō, vers 1835–42.
Sur l'estampe *Lune d'automne sur Tamagawa* (Planche 12) les branches du saule ondoient de façon harmonieuse sous l'effet d'une brise qui souffle le long de la rivière, sous une nuit claire. *Seba* représente le même type de berge, mais quelle différence! Le vent qui souffle vers les champs est d'une âpreté indiscutable. Même les roseaux sur le bord de l'eau produisent un bruissement tapageur, et de plus il y a quelque chose de mystérieux dans la rougeur des nuages. Et pourtant il n'y a pas dans la nature l'ordre qui existe sur la gravure. Hiroshigé a éliminé les éléments inutiles de la nature et il a créé un ordre nouveau et structuré, faisant montre d'une sensibilité subtile pour les formes structurelles.

20. *Marché du premier de l'An au Temple d'Asakusa*, appartenant à la série "Lieux célèbres de la capitale orientale" (*Tōto meisho: Asakusa Kynryūzan toshi no ichi*). Format *Ōban*. Publiée par Sanoki, vers 1842.

21. *Foule du quartier des théâtres*, appartenant à la série "Lieux célèbres de la capitale orientale" (*Tōto meisho: Shibai-chō hau'ei no zu*). Format *Ōban*. Publiée par Yamamoto, vers 1845. (Pour une autre estampe de la même série se reporter à la Planche 26).
Sur l'estampe du Temple d'Asakusa, les étals des marchand couvrent les jardins du Temple, et parmi eux on distingue une mer de parasols recouverts de neige. A gauche, l'entrée du temple de Kannon est encombrée de monde tandis que la neige continue à tomber. C'est cet ensemble d'éléments hétéroclites qui rend cette estampe fascinante. Même lorsqu'il représente la cohue sur la place du marché, comme ici, avec un parfait contraste du rouge et du blanc, Hiroshigé transmet pratiquement toujours une sensation de quiétude. *Foule du quartier des théâtres* est une oeuvre remarquable qui représente, à l'encontre de la gravure précédente, une scène aux activités tumultueuses. Chose également insolite pour Hiroshigé, ici, c'est la forte sensation de perspective *uki-e*, qui dérive d'études japonaises de l'art occidental. On remarquera que ces deux estampes appartiennent à des séries différentes, bien que les titres soient identiques.

22. *Averse sur Nihonbashi*, appartenant à la série "Lieux célèbres de la capitale orientale" (*Tōto meisho: Nihonbashi no hakuu*). Format *Ōban*. Publiée par Kikakudō, vers 1834–35. (Pour une autre estampe de la même série se reporter à la Planche 23).
Une averse s'abat sur Nihonbashi, le pont le plus célèbre d'Edo et point à partir duquel toutes les distances au Japon étaient mesurées. Sur la rive éloignée de la rivière se dressent des rangées de magasins solidement bâtis, aux murs blancs, tandis qu'à l'horizon on aperçoit le château d'Edo. L'aspect particulier de cette gravure est une structure pittoresque que l'on peut reconnaître à travers une combinaison de formes architectoniques telles des berges en pierre, un château, des magasins aux murs de terre et un pont. Il s'agit d'une scène austère à la

beauté nettement définie, sûre d'elle-même. Alors que la merveilleuse scène de neige nocturne à *Kanbara* (planche 5) est d'une beauté que l'on pourrait définir de lyrique, ici il s'agit d'une poésie nouvelle des formes structurelles. Sur les vingt-neuf estampes de cette série, *Averse sur Nihonbashi* se distingue certainement par son excellence.

23. *Au sommet du Mont Atago dans le district de Shiba*, appartenant à la série "Lieux célèbres de la capitale orientale" (*Tōto meisho: Shiba Atago sanjō no zu*). Format *Ōban*. Publiée par Kikakudō, vers 1834–35 (Pour une autre estampe de la même série se reporter à.la Planche 22).

24. *Cerisiers en fleurs le long de la Sumida*, appartenant à la série "Lieux célèbres de la capitale orientale" (*Tōto meishi: Sumida-gawa hanazakari*). Format *Ōban*. Publiée par Kawashō, vers 1840–1842.

25. *Dernier rayon de soleil à Imado*, appartenant à la série "Lieux célèbres de la capitale orientale: Huit vues de la Sumida" (*Tōto meisho nu uchi: Sumida hakkei: Imado yūshō*). Format *Ōban*. Publiée par Sanoki, vers 1840–42.

26. *Shinobatzu, le lac des fleurs de lotus à Ueno*, appartenant à la série "Lieux célèbres de la capitale orientale" (*Tōto meisho: Ueno Shinobatzu hasuike*). Format *Ōban*. Publiée par Yamamoto, vers 1845. (Pour une autre estampe de la même série se reporter à la Planche 21).
Au fur et à mesure qu'Hiroshigé gagne en popularité, il peint un nombre très important de paysages de lieux célèbres à Edo, à la demande de divers éditeurs. Il existe plus de cinquante variétés dans une même série, chaque série ayant de dix à trente estampes, il est peut-être normal que plusieurs séries portent le même titre. Si l'on ajoute aux séries les estampes à un seul volet, on arrive à un chiffre fort élevé. On remarquera également que pour la gravure de la Planche 25, une de celles aux tons clairs, Hiroshigé a évité de faire usage de l'encre noire pour tracer les contours.

27. *Le trèfle et la grenouille*, appartenant à la série d'estampes pour éventails fixes "Fleurs des quatre saisons" (*Shiki no hana zukushi: Hagi to kaeru*). Publiée par Ibasen, vers 1843–47.

28. *Héron cendré parmi les joncs* (*Futoi ni shirasagi*). Format *Chu-tanzaku*. Publiée par Kawasho, vers 1834. Musée d'Art Riccar, Tokyo.
A part les oeuvres de ses dernières années, une quantité importante des paysages d'Hiroshigé sont caractérisés par la tonalité obtenue à l'aide de l'encre noire et de l'indigo, les autres couleurs ayant un rôle secondaire. Les e tampes du petit oiseau et des fleurs montrent que les tableaux d'Hiroshigé sont riches en tons clairs. Dans l'estampe du héron la souplesse des plumes est obtenue par la couleur environnante sans pour cela tracer les contours à l'encre noire. De plus, le plumage a été représenté au moyen d'une incision à sec, technique que l'on n'aperçoit toutefois pas sur la gravure et qui accentue la beauté du blanc.

29. *Fleurs de cerisiers et petit oiseau* (*Sakura ni shōkin*). Format *Ōtanzaku*. Editeur inconnu, vers 1832. Musée d'Art Riccar, Tokyo.

30–33. *Printemps: Fleurs de cerisier à Gotenyama; Eté: Lune au pont de Ryōgoku; Automne: Erables au temple de Kaianji; Hiver: Neige le long de la Sumida*, appartenant à la série "Lieux célèbres d'Edo au cours des quatre saisons" (*Shiki Edo meisho: Haru: Gotenyama no hana; Natsu: Ryōgoku no tsuki; Aki: Kaianji no kōfū; Fuyu: Sumidagawa no yuki*). Format *Chū-tanzaku*. Publiées par Kawashō, vers 1834.
Il s'agit ici d'une des premières séries de format *tanzaku*, chaque estampe étant une oeuvre méticuleuse fort riche du lyrisme propre à Hiroshigé. Dans l'estampe *Printemps*, la douceur d'une journée de printemps sans vent est habilement exprimée par une structure composée de lignes horizontales et verticales, telle la ligne de l'horizon qui se dirige vers le centre du tableau, les panneaux indicateurs et les mâts des navires. Les doux rayons du soleil printanier sont perçus dans le rose tendre des fleurs de cerisier et dans le vert frais de la pente herbeuse. Gotenyama, colline qui fait face à la mer à l'ouest de la station de Shinagawa sur la Tōkaidō, était renommée pour la beauté de ses cerisiers en fleur.
Le pont de Ryōgoku, qui enjambe la Sumida à Edo, était l'endroit préféré où l'on se retrouvait durant les chaudes soirées d'été. Sur l'estampe *Eté* le pont et la rivière sont représentés sous une pleine lune. Dans le lointain on aperçoit deux ou trois jonques et au premier plan un vendeur ambulant de melons, figure familière qui se fraye un chemin à travers les jonques offrant sa marchandise. Nous sommes en

début de soirée, il y a encore très peu de monde sur la rivière – moment de tranquilité capturé de façon magistrale.

Le temple de Kaianji, situé sur une colline adjacente à celle de Gotenyama, dominait la mer et en automne les coloris merveilleux des érables attiraient les habitants d'Edo pour d'agréables randonnées. Il est possible que le personnage sur la gauche de la gravure *Automne*, habillé à la façon d'un compositeur de *haikai*, soit en fait Hiroshigé même.

La neige tombe incessamment, un homme pousse un radeau, une berge et des troncs qui se déplacent au hasard.... *L'Hiver* est une composition simple et pourtant on retrouve dans cette scène la profonde tranquillité si caractéristique d'Hiroshigé. C'est ici le monde propre à Hiroshigé, un monde en indigo et en noir. Les flocons de neige qui complètent la composition – cristaux blanc sur un fond multicolore – produisent un vif effet décoratif.

34. *Marchands prospères à Ongyoku-machi* (*Ongyoku-machi hanka no shōnin*: partie supérieure). Estampe pour éventail fixe. Publiée par Ibasen, vers 1852.

35. *La danse Bon*, appartenant à la série "Compendium de danses anciennes" (*Kodai odori zukushi*: *Bon odori*, partie inférieure). Estampe pour éventail fixe. Publiée par Ibakyu, vers 1843–47.
Qu'est-ce qu'un "Compendium de danses anciennes" et combien d'estampes comportait-il à l'origine? Y avait-il un modèle sur lequel Hiroshigé a basé son estampe, ou s'agit-il de sa propre création? En fait on n'en sait rien. Les personnages qui apparaissent sur les paysages d'Hiroshigé sont généralement habilement représentés, aussi bien sur le plan de la forme que sur celui de la pose, par de simples coups de pinceau qui mettent en relief un certain charme. Même dans la *Danse Bon* Hiroshigé a pris plaisir a représenter le vieux et le jeune, les hommes et les femmes, dans des poses humoristiques. Dans *Marchands prospères à Ongyoku-machi* la caricature réside dans le fait que les marchands et les clients sont représentés comme des artistes.

36. *Scène nocturne à Saruwaka-chō*, appartenant à la série "Lieux célèbres d'Edo: Cent vues" (*Meisho Edo hyakkei*: *Saruwaka-chō yoru no kei*). Format *Ōban*. Publiée par Uoei, 1856–59.
Cette série, oeuvre des dernières années d'Hiroshigé, se compose de vingt huit estampes, plus une réalisée par Hiroshigé II; de celles attribuées à Hiroshigé, cependant, on suspecte que trois sont des faux. L'estampe qui est représentée ici dépeint une foule dans Saruwaka-chō sous la lune, le quartier des théâtres d'Edo, toutefois la scène est d'un calme absolu par suite de l'immobilité des personnages. Qu'il représente des gens admirant les fleurs de cerisiers à Gotenyama ou l'émotion ressentie par la représentation de feux d'artifice au pont de Ryōgoku, généralement Hiroshigé s'éloigne de tout type d'excitation, dépeignant la scène calmement et de loin. L'estampe qui est illustrée ici appartient au premier tirage. Sur les tirages postérieurs, la lune est beaucoup plus basse et l'ombre qui apparaît sous la lune a été omise, tout comme le noir sous les avant-toits des maisons. On relèvera tout particulièrement les ombres des personnages sur la surface claire du sol, innovation stylistique qui confère une certaine fraîcheur à la scène.

37. *Bourrasque du soir le Grand Pont d'Atake*, appartenant à la série "Lieux célèbres d'Edo: Cent vues" (*Meisho Edo hyakkei*: *Ōhashi Atake no yūdachi*). Format *Ōban*. Publiée par Uoei, 1856–59.
La surface de la rivière qui brille sous l'averse, Atake-chō qui apparaît de façon peu distincte à travers la pluie, les gens qui s'affairent sur le pont... la représentation habile par Hiroshigé des scènes de pluie reste parfaite, même dans une scène comme celle-ci réalisée au cours des dernières années de sa vie. Il s'agit ici du chef-d'oeuvre d'une série qui comporte un grand nombre d'estampes utilisant des couleurs sombres. L'ombre de la surface de l'eau à gauche en haut et à droite en bas, de même que celle sur le pont, ont été omises sur les tirages postérieurs. Il existe également une variante sur laquelle deux barques supplémentaires ont été rajoutées à l'encre noire. La scène est raffermie par les nuages noirs qui recouvrent l'extrémité supérieure du tableau.

German Text

1. *Takanawa unter einem Herbstmond,* aus der Serie "Berühmte Stätten der östlichen Hauptstadt" (*Tōto meisho: Takanawa no meigetsu*). *Ōban*-Format. Veröffentlicht von Kawaguchi Shōzō, *ca.* 1831.
Diese Serie besteht aus zehn Drucken, wobei jeder eingerahmt ist und als Aufschrift "Bild von Ichiryūsai Hiroshige" trägt. In *Takanawa unter einem Herbstmond,* wo eine Gänseherde groß in der Mitte der Szene gemalt ist, herrscht eine Kühnheit in der Komposition, die häufig in dieser Serie erscheint, so wie die Brückenpfeiler vollständig in den Vordergrund in *Ryōgoku unter einem Abendmond* (Tafel 2) gerückt sind. Diese Methode gilt als Einfluß von Hokusai. Um aber den Betrachter nicht nach Hokusais Art zu überraschen, scheint Hiroshige vorzuhaben, eine breite Fläche offenen Landes durch den Gegensatz zwischen Vordergrund und ferngelegener Szene zu malen. Diese Serie stellt Hiroshiges ersten Versuch auf dem Gebiet der Landschaftsdrucke im *ōban*-Format dar und stellt einen frischen jugendlichen Stil vor. Durch ihn entdeckte Hiroshige in Landschaften das Genre, das seinem Temperament am meisten lag.

2. *Ryōgoku unter einem Abendmond,* aus der Serie "Berühmte Stätten der östlichen Hauptstadt" (*Tōto meisho: Ryōgoku no yoizuki*). *Ōban*-Format. Veröffentlicht von Kawaguchi Shōzō, *ca.* 1831.
Dieser Druck ist einer von zwei Varianten. In dem üblicherweise abgebildeten sind die Querstützpfeiler der Brücke und die Häuser am weiter entfernten Ufer in Ocker gedruckt. Hier habe ich nun die weniger bekannte, vorwiegend in indigoblau (*aizuri*) gedruckte Fassung miteinbezogen, von denen diese Serie noch mehr enthält. Eine Gruppe roter, tief, dicht am Horizont liegender Wolken in Ocker-Druck ist aus dieser Variante völlig ausgeschaltet worden. Auf Hiroshiges Einfluß auf den amerikanischen Maler Whistler ist von verschiedenen Seiten hingewiesen worden, und dieser Druck erinnert an Whistlers Bild, *Die alte Battersea-Brücke* (Fig. 10).

3. *Mariko,* aus der Serie "Dreiundfünfzig Haltestellen auf dem Tōkaidō" (*Tōkaidō gojū-san tsugi no uchi: Mariko*): *Ōban*-Format. Veröffentlicht von Hōeidō, 1832–34.
Hier hat Hiroshige gegen eine ländliche Szene ein Geschäft gemalt, das Marikos berühmte, aus geriebenen Yamswurzeln zubereitete Brühe verkauft; das schräge Schild vor dem Laden preist die Ware an. Die Idee für diese Szene stammt vielleicht aus der Geschichte der komischen Reisenden, Yaji und Kita, in dem Roman, *Unterwegs auf Schusters Rappen auf dem Tōkaidō,* und aus Bashōs *haiku:*
> Junge Pflaumenbaumblätter
> Und an der Mariko-Wegstation
> Eine Geriebene-Yam-Brühe.

Von der roten Schattierung des Himmels und dem frischen, geschickt am Fuß des Berges hineingedruckten Grün her kommt ein Gefühl der erfrischenden Natur des Vorfrühlings, wie denn Hiroshige immer seinen Landschaften einen der Jahreszeit entsprechenden Anstrich gibt. In der ersten Ausgabe des Druckes wurden andere Buchstaben für den oben links hingeschriebenen Namen 'Mariko' gebraucht; abgesehen davon weisen spätere Drucke keine merklichen Unterschiede vom Original auf.

4. *Numazu,* aus der Serie "Dreiundfünfzig Haltestellen auf dem Tōkaidō" (*Tōkaidō gojū-san tsugi no uchi: Numazu*). *Ōban*-Format. Veröffentlicht von Hoeido, 1832–34.
Nachts zu Fuß auf der Straße zur Wegstation ziehen ein Vater und sein Kind auf der Wallfahrt hin und auch ein Mann, der eine große Maske des sagenhaften Gottes Sarudahiko auf dem Rücken trägt, das Kinpira-Heiligtum zu besuchen. Die Straße biegt um und führt nach links. Vorne gehen andere Reisende, den Kopf hängen lassend, während die Brücke unser Auge weiter zur Häuserreihe an der Wegstation lenkt. Wir, die Betrachter, gehen auf der Straße mit den Reisenden und fühlen die Strecke, denn die Komposition gibt den Eindruck von Tiefe. Über der Häuserreihe befindet sich ein großer Vollmond gerade im Aufgehen. Ein lediglich durch Anwendung von blauer und schwarzer Tusche erreichter zarter Ton ist geeignet, das Dunkel der Nacht und die Helle der mondbeschienenen Luft zu vermitteln. Die Wasser-Oberfläche ist auch erhellt, vielleicht durch den Mond, und das Ganze stellt eine ruhige und einsame Straßenlandschaft dar.

5. *Kanbara,* aus der Serie "Dreiundfünfzig Haltestellen auf dem Tōkaidō" (*Tōkaidō gojū-san tsugi no uchi: Kanbara*). *Ōban*-Format. Veröffentlicht von Hōeidō, 1832–34.
Dieser Druck existiert in zwei Versionen. Eine hat oben auf dem Druck einen dunklen Tuschenstreifen, der in das Mattgrau eines hellen Himmels unten übergeht; die andere, hier wiedergegebene ist genau das Gegenteil: der die Häuser und die Berge unten berührende Himmel ist in schwarzer Farbe gedruckt und geht in einen hellen Himmel oben über. Die erstere gilt als der erste Druck; hier ist jedoch der spätere Druck abgebildet, weil er die Tiefe und das Schweigen der Nacht und das wundervolle Schwarz-Weiß wirkungsvoller ausdrückt. Sowohl bei der Einsamkeit der verschneiten, in der Tiefe der Nacht schlafenden Wegstation wie bei den der Szene eine menschliche Seite verleihenden Gestalten wird dem Zuschauer warm ums Herz.

6. *Shōno,* aus der Serie "Dreiundfünfzig Haltestellen auf dem Tōkaidō" (*Tōkaidō gojū-san tsugi no uchi: Shōno*). *Ōban*-Format. Veröffentlicht von Hōeidō, 1832–34. National-Museum Tokio.
Die bei Hiroshige seltene Szene stellt heftige Bewegung dar. Die Schärfe des Regens teilt sich durch seine dicken Stränge und den spitzen Fallwinkel mit und die abwechselnden Flächen mit starkem und leichterem Regenguß. Eine gewisse Ordnung hat sich in der Bewegung der Bäume eingestellt. Das Gehege im Hintergrund, das sich unter einem plötzlichen Windstoß schaudernd biegt, erstreckt sich von rechts nach links in grauen Bogen und gibt ein Gefühl mächtiger Bewegung. Hiroshige hat das Ungestüm des Sturzbachs meisterhaft gezeichnet, wie er die Menschen im Gewimmel und die so plötzlich durch den Wolkenbruch in der Umgebung hervorgerufene Unruhe geschickt faßt. Mit der kräftigen Farbe des Grases auf dem ansteigenden Weg hat er einen der Jahreszeit entsprechenden Anstrich hinzugefügt.

7. *Fukuroi,* aus der Serie "Dreiundfünfzig Haltestellen auf dem Tōkaidō (*Tōkaidō gojū-san tsugi no uchi: Fukuroi*). *Ōban*-Format. Veröffentlicht von Hōeidō, 1832–34. Riccar Kunstmuseum Tokio.
Eine durch einen Rohrvorhang geschützte primitive Teestube ist an der Straße in gewissem Abstand von der Wegstation dargestellt. In der linken Hälfte des Druckes hat Hiroshige in einem den Tee-Ausschank enthaltenden Vordergrund Menschen und einen Baum gezeichnet; in

der rechten Hälfte hat er eine breite Fläche freien Raums aufgebaut. Dies ist eine von Hiroshige gern gebrauchte Komposition, mit dem Kontrast zwischen links und rechts, zwischen Aussicht und Vordergrund und zwischen größerer und geringerer Dichte der dargestellten Gegenstände. Reisende bleiben stehen, um zu rauchen, während die Besitzerin des Tee-Ausschanks das Feuer schürt und sich dabei vom Rauch abwendet. Diese Szene könnte überall am Wege zu sehen sein, und die Geschicklichkeit, mit der das Verhalten und Auftreten der verschiedenen Leute dargestellt ist, ist bemerkenswert. In der recht einfachen rechten Hälfte der Szene ist der kleine Vogel auf dem Schild vollendet angeordnet.

8. *Mitsuke,* aus der Serie "Dreiundfünfzig Haltestellen auf dem Tōkaidō (*Tōkaidō gojū-san tsugi no uchi: Mitsuke*). *Ōban*-Format. Veröffentlicht von Hōeidō, 1832–34.
Mitsuke war eine Wegstation östlich des Tenryū-Flusses. Reisende aus der Kyoto-Osaka-Gegend, dem sog. Kamigata, auf dem Weg nach Edo erblickten den Fuji-Berg zuerst von hier aus, und so wurde dieser Ort angeblich "Mitsuke" oder "Erblicken" benannt. Das Bild zeigt die Fähre beim Überqueren des Tenryū-Flusses im Sprühregen. Die auf der Sandbank auf das Boot wartenden Reisenden sind in Regenmäntel eingehüllt, und das Pferd hat ein Bündel, das ebenfalls auf Regen vorbereitet ist. Die Aussicht über den Fluß hinaus ist durch den Sprühregen verdeckt. Die Ruderleute im Vordergrund, dem Zuschauer den Rücken kehrend, haben den für Hiroshiges Gestalten typischen, liebenswürdigen Ausdruck. Obwohl es sich hierbei um eine Landschaft handelt, ist die von den Menschengestalten im Vordergrund und in der mittleren Entfernung gespielte Rolle außergewöhnlich; ohne sie würde das Bild seine ganze Lebendigkeit verlieren.

9. *Der Yodo-Fluß,* aus der Serie "Berühmte Stätten von Kyoto" (*Kyōto meisho no uchi: Yodogawa*). *Ōban*-Format. Veröffentlicht von Eisendō, ca. 1835.
Die Leute auf dem Boot sind äußerst anschaulich dargestellt: eine Frau wiegt einen Säugling, ein Mann hat einen Ellbogen aufgestützt und döst, ein weiß gekleideter Pilger auf der Wallfahrt zum Kinpira-Berg kommt aus seiner Schläfrigkeit heraus. Eine Vielfalt von Bewegung ist bei den Ruderleuten des großen Schiffs ersichtlich, und das danebenliegende kleine Boot mit der Nahrungsmittel-Auslage ist sehr detailliert ausgearbeitet. Das sog. Dreißig-*koku*-(etwa 1,2-Tonnen-) Boot, mit dicken Strichen und mit deutlicher Ausarbeitung des Aufbaus im einzelnen gezeichnet, hat zahlreiche Passagiere an Bord und fährt doch ruhig dahin. Die Leute an Bord, ihr Verhalten und ihre Eigenarten scheinen den Mittelpunkt der Aufmerksamkeit zu bilden, aber die Flußabwärts-Fahrt ist geschickt mit der natürlichen Umgebung durch das klare Indigoblau des Himmels und der Wasser-Oberflächen mit ihren beschatteten Flächen und dem Vollmondlicht verbunden.

10. *Kirschbäume in voller Blüte in Arashiyama,* aus der Serie "Berühmte Stätten von Kyoto" (*Kyōto meisho nu uchi: Arashiyama manka*). *Ōban*-Format. Veröffentlicht von Eisendō, ca. 1835.
Die Bäume auf dem fernen Ufer, das Grün am Wasserrande, selbst der Rauch des Feuers auf dem Floß neigen sich schräg nach rechts; die ganze Komposition bewegt sich langsam von links nach rechts. Die Szene ist friedlich, und ein Floß schwimmt langsam stromabwärts durch einen Haufen von Kirschblüten. In der dünnen schwarzen Tuschen-Tönung des fernen Ufers sind nur die Kirschen hell und hübsch und geben den hellen Beginn des Indigoblaus auf dem Fluß wieder. Es ist eine neue Kompositionsform, in welcher der Fluß breit eingezeichnet und das ferne Ufer mit den blühenden Kirschbäumen schräg gezeichnet ist. Obwohl einer Anzahl von Drucken in dieser Serie Abbildungen zugrundeliegen, die in früher veröffentlichten Druckwerken wie *Abbildungen berühmter Stätten von Miyako [Kyoto]* zugänglich waren, sind die hier vorliegenden von besonders hoher Qualität.

11–12. *Heimkehrende Segelboote in Gyōtoku; Herbstmond über Tamagawa:* aus der Serie "Acht Ansichten der Umgebung von Edo" (*Edo kinkō hakkei no uchi: Gyōtoku kihan; Tamagawa shūgetsu*). *Ōban*-Format. Veröffentlicht von Kikakudō, ca. 1835–39. Riccar Kunstmuseum Tokio.
Zu den frühen Drucken dieser Serie gehörten komische *kyōka*-Gedichte wie auf diesen beiden Drucken, und sie fanden bei Käufern mit Vorlieber für *kyōka* Absatz. Es besteht also eine enge Beziehung zwischen dem Bild und den dabeistehenden Gedichten. Später wurden die Drucke jedoch ohne die Gedichte herausgegeben. In *Heimkehrende Segelboote in Gyōtoku* weist nur das im Vordergrund im Winkel angeordnete Boot einen Ausdruck der Bewegung auf, umgeben von der Friedlichkeit einer vorwiegend aus senkrechten und waagerechten Linien bestehenden Komposition. Dieser Druck stellt eine der helleren Szenen unter den acht Ansichten der Serie dar. Im ersten Druck von *Herbstmond über Tamagawa* war der Mond in Silberfarbe gedruckt. Siehe Tafel 13 zu einem Werk aus der ersten Ausgabe dieser Serie.

13. *Abendschnee in Asukayama,* aus der Serie "Acht Ansichten der Umgebung von Edo" (*Edo kinkō hakkei no uchi: Asukayama no bosetsu*). *Ōban*-Format. Veröffentlicht von Taihaidō, ca. 1835–39. Ōta-Gedächtnis-Kunstmuseum Tokio.
Die Qualität dieses Druckes beruht auf wechselnden Farbtönen dünner schwarzer Tusche. Wegen technischer Schattierungs-Schwierigkeiten erschienen bei diesem Bild nach dem jeweiligen Druck geringfügige Abweichungen. Daß jeder Druck auf seine Art einen gut ausgeglichenen Farbton besitzt, liegt wohl an der außerordentlich großen, bei der Druckarbeit verwendeten Sorgfalt. Die in den linken Rand gedruckten Buchstaben, 'Veröffentlicht von Taihaidō', erschienen auf dem ersten Druck, der in kleiner, für Freunde bestimmter Auflage hergestellt wurde und heutzutage kaum erhältlich ist. Daraus, daß der ununterbrochen fallende Schnee auf jedem Druck mit dem Pinsel hineingemalt worden ist, folgt, daß bei zwei Drucken der Schnee nie der gleiche ist. In der allgemein käuflich zu erwerbenden Version hat es aufgehört zu schneien. Siehe Tafel 11–12 zu Werken einer späteren Ausgabe der gleichen Serie.

14. *Nacht-Regen in Karasaki,* aus der Serie "Acht Berühmte Ansichten der Provinz Ōmi" (*Ōmi hakkei no uchi: Karasaki yau*). *Ōban*-Format. Veröffentlicht von Eisendō, ca. 1835–39.
Von diesem Druck bestehen zwei Versionen, eine schwarz, die andere indigoblau. Diese Serie wurde als "eine Serie von Bildern in gedämpften Farben im Stile der alten Monochrom-Arbeiten" angeboten, und es wurde allgemein angenommen, daß es sich bei dem Druck, auf welchem der alte Tannenbaum völlig in schwarzer Tusche ausgeführt ist, wie er sich gewöhnlich in Abbildungen befindet, um den Druck zum Verkauf an das allgemeine Publikum handelte. In beiden Drucken hüllt eine große Stille die alte Tanne von Karasaki ein, wie sie in der Nacht hochragt, halbverdunkelt im platschenden Wolkenbruch. Nach den unbeschädigten Blöcken zu urteilen, scheint es, daß es sich bei dem indigoblauen Druck um einen verhältnismäßig frühen Versuch Hiroshiges gehandelt hat. Obwohl dem Bild der Ausdruck des Nacht-Regens weitgehend fehlt, übergeht man doch nicht gern diese klaren Indigo-Farbtöne zugunsten der schwarzen Version.

15. *Karuizawa,* aus der Serie "Neunundsechzig Haltesetellen auf dem Kisokaidō" (*Kisokaidō rokujū-kyū tsugi no uchi: Karuizawa*). *Ōban*-Format. Veröffentlicht von Kinjūdo, ca. 1835–42.
Auf dieser Landschaft ist die Sonne untergegangen; es ist anscheinend eine Straße in der Nähe einer schon dunklen Wegstation: Feuer brennen mit rotem Licht, und die Reisenden finden Feuer für ihre Pfeife. Von dem Grün des Bodens abgesehen, sind der Berg, die Bäume und die Häuserreihe alle in Schattierungen schwarzer Tusche gemalt. In das Dunkel der Nacht gehüllt, sind nur die Männer und das Pferd im Vordergrund in Farbe herausgearbeitet. Die Stellen, die das Licht abfangen, wurden hell gefärbt, wo absichtlich besonders hell, wo der Baum durch das Feuer erhellt und wo der Mann zu Pferde durch den Lampion beleuchtet ist,—eine in Hiroshiges Zeit seltene Arbeitsweise und einer der Feinheiten dieses Druckes. Zu dem Rauch des Feuers sind außerdem Abstufungen in Helligkeit hinzugekommen, und auf dem Lampion sind die Buchstaben des Namens des Verlegers zu sehen.

16. *Mochizuki,* aus der Serie "Neunundsechzig Haltestellen auf dem Kisokaidō (*Kisokaidō rokujū-kyū tsugi no uchi: Mochizuki*). *Ōban*-Format. Veröffentlicht von Kinjūdo, ca. 1835–42.
In der Richtung einer schrägen Linie führt die Straße an einem langsam steigenden Abhang vorbei, ehe sie jenseits des Passes links steigenden Abhang vorbei verschwindet. Die Linie der Wurzeln und Hügel am Boden der Tannen-Reihe sowie die Linie der auf der Straße gehenden Leute kommen auf der Paßhöhe zusammen und verursachen dadurch einen starken Ausdruck von Tiefe. Das Unnatürliche bei der elementaren Perspektiven-Arbeit des *uki-e,* die auf westliche Perspektiven-Anschauungen zurückgeht, ist verschwunden, und hier haben wir es mit einer realistischen, naturbedingten Darstellung zu tun. Von der Paßhöhe nach links werden die Baumkronen immer niedriger, und wir bekommen jenseits des Passes die auftauchende Oberhälfte eines Reisenden zu sehen. Hiroshiges Realismus wird in seinem Bestreben deutlich, uns die Vorstellung zu geben, daß die

Straße jenseits des Passes weitergeht. Rechts liegt ein tiefes Tal, aus dem Berge und Bäume aufwärts ragen.

17. *Mieji*, aus der Serie "Neunundsechzig Haltestellen auf dem Kisokaidō" (*Kisokaidō rokujū-kyū tsugi no uchi: Mieji*). *Ōban*-Format. Veröffentlicht von Kinjudō, *ca.* 1835–42.
Der Himmel im Westen ist rot, und der Wald in der Ferne und Schatten hier und dort werden dunkel; nur der Himmel bleibt hell und klar, und das den Himmel spiegelnde Wasser in den Reisfeldern leuchtet weiß. Dieser Druck drückt den schönen Augenblick, in dem die Sonne gerade untergegangen ist, wundervoll aus. Ein Reisender, der gerade die bergabgehende Straße heruntergekommen ist, scheint sich nach dem Weg zur Wegstation für diesen Abend zu erkundigen. Hiroshige wählt stets den frühen Morgen, Abend oder die späte Nacht für seine Szenen und bringt Leute hinein, wie sie in den dargestellten Platz passen, wodurch die Szene eine geschmackvolle Atmosphäre erhält. Die roten Kamelien sind besonders hübsch. Bei diesem Druck, wie bei anderen, legt Hiroshige Nachdruck auf die einzelnen Elemente mit Hilfe eines Kompositions-Aufbaus, in dem einfache Beschreibung in die linke Hälfte kommt und dagegen die rechte Hälfte mit Flora und Leuten ausgefüllt wird.

18. *Tarui*, aus der Serie "Neunundsechzig Haltestellen auf dem Kisokaidō" (*Kisokaidō rokujū-kyū tsugi no uchi: Tarui*). *Ōban*-Format. Veröffentlicht von Kinjudō, *ca.* 1835–42.
Links und rechts kauern sich Leute auf der Wegstation nieder; sie kommen heraus, um Gäste zu begrüßen. Ein Mann mit einem Regenschirm und mit etwas gebückten Körper gehend, dient als Führer für die beiden Reihen einer Prozession, am Ende derer eine Sänfte zu sehen ist. Dies ist der feierliche Einzug eines großen Lehnsherrn in die Wegstation, und, was bei Hiroshige selten vorkommt, die Szene ist förmlich und symmetrisch links und rechts eingeteilt, mit den an der Straße stehenden Bäumen im Mittelpunkt. Die Männer am Kopf der ankommenden Kolonnen sind mit ihren Füßen bis zu den Knöcheln eingesunken, da der Regen die Straße schlammig gemacht hat: ein Merkmal, das Hiroshiges Beobachtung kleiner Einzelheiten veranschaulicht. Bemerkenswert sind die Holzschnitt-Drucke von schönen Frauen, dem Fuji-Berg und Landschaften von Edo im Teehaus rechts.

19. *Seba*, aus der Serie "Neunundsechzig Haltestellen auf dem Kisokaidō" (*Kisokaidō rokujū-kyū tsugi no uchi: Seba*). *Ōban*-Format. Veröffentlicht von Kinjudō, *ca.* 1835–42.
In dem Druck *Herbstmond über Tamagawa* (Tafel 12) sehen wir einen klaren Nachthimmel, unter dem sich die Weidenzweige in einer das Flußbett entlang wehenden Brise leicht wiegen. Seba stellt die gleiche Art Flußbett dar; aber welch ein Unterschied! Der über die offenen Felder wehende Wind weist eine gewisse Härte auf. Selbst das Schilfrohr am Wasserrand raschelt geräuschvoll, und es liegt etwas Unheimliches in der Röte der Wolken. Und doch ist die Natur nicht ganz so gut geordnet. Hiroshige hat überflüssige Elemente aus dem Überfluß der Natur ausgeschaltet, und er hat eine neue gegliederte Ordnung geschaffen und damit Feinfühligkeit für Bauformen bewiesen.

20. *Neujahrs-Markt am Asakusa-Tempel*, aus der Serie "Berühmte Stätten der östlichen Hauptstadt" (*Tōto meisho: Asakusa Kinryūzan toshi no ichi*). *Ōban*-Format. Veröffentlicht von Sanoki, *ca.* 1842.

21. *Menschenmassen im Theater-Viertel*, aus der Serie "Berühmte Stätten der östlichen Hauptstadt" (*Tōto meisho: Shibai-chō han'ei no zu*). *Ōban*-Format. Veröffentlicht von Yamamoto, *ca.* 1845. (Siehe Tafel 26 zu einem anderen Druck aus dieser Serie).
Im Asakusa-Tempel-Druck ist das Tempelgebiet von Marktständen erfüllt, und zwischen ihnen liegt ein Meer von schneebedeckten Regenschirmen. Die Kannon-Halle links ist ebenfalls von Menschenmassen gefüllt, und der ganze Himmel ist voll von ständig fallendem Schnee. All diese Anhäufung verschiedener Elemente gibt diesem Druck seinen Reiz. Selbst wo er wie hier das Gedränge der Massen auf dem Marktplatz malt,—rot und weiß wundervoll gegenübergestellt,—ist es typisch für Hiroshige, daß die Stimmung im ganzen fast immer ruhig ist. *Menschenmassen im Theater-Viertel* ist daher insofern recht außergewöhnlich, als es eine Szene stürmischen Treibens darstellt. Ebenfalls ungewöhnlich für Hiroshige ist hier die ausgeprägte *uki-e* Perspektive, die auf japanische Studien westlicher Kunst zurückgeht. Es ist zu beachten, daß diese beiden Drucke aus verschiedenen Serien stammen, obwohl die Titel identisch sind.

22. *Regenschauer auf Nihonbashi*, aus der Serie "Berühmte Stätten der östlichen Hauptstadt" (*Tōto meisho: Nihonbashi no hakuu*). *Ōban*-Format. Veröffentlicht von Kikakudō, *ca.* 1834–35. (Siehe Tafel 23 zu einem anderen Druck aus dieser Serie.)
Ein paar Regentropfen fallen auf Nihonbashi, Edos berühmteste Brücke und die Stelle, von der aus in Japan alle Entfernungen gemessen wurden. Auf dem fernen Ufer des Flusses stehen Reihen stabil gebauter Lagerhäuser mit weißen Mauern, und in der Entfernung kann man die Edo-Burg sehen. Dieser Druck ist auf eine feste Bildstruktur ausgelegt, die sich aus solch stabilen Bestandteilen wie Steindämmen, einer Burg, Lagerhäusern mit Erdmauern und der Brücke zusammensetzt. Die Szene vermittelt eine strenge Kraft und eine deutliche und selbstbewußte Schönheit. Während die wundervolle Schneelandschaft in der Nacht in *Kanbara* (Tafel 5) eine geradezu lyrische Schönheit besitzt, handelt es sich hier um eine neue Poesie von Bauformen. Unter den neunundzwanzig Drucken dieser Serie fällt die hervorragende Qualität von *Regenschauer auf Nihonbashi* besonders auf.

23. *Auf dem Atago-Berg im Shiba-Gebiet*, aus der Serie "Berühmte Stätten der östlichen Hauptstadt" (*Tōto meisho: Shiba Atago sanjō no zu*). *Ōban*-Format. Veröffentlicht von Kikakudō, *ca.* 1834–35. (Siehe Tafel 22 zu einem anderen Druck aus dieser Serie.)

24. *Kirschbäume in Vollblüte am Sumida-Fluß*, aus der Serie "Berühmte Stätten der östlichen Hauptstadt" (*Tōto meisho: Sumidagawa hanazakari*). *Ōban*-Format. Veröffentlicht von Kawashō, *ca.* 1840–42.

25. *Abendrot in Imado*, aus der Serie "Berühmte Stätten in der östlichen Hauptstadt: Acht Ansichten des Sumida-Flusses" (*Tōto meisho no uchi: Sumida hakkei: Imado yūshō*). *Ōban*-Format. Veröffentlicht von Sanoki, *ca.* 1840–42.

26. *Shinobazu-Lotus-Teich in Ueno*, aus der Serie "Berühmte Stätten der östlichen Hauptstadt" (*Tōto meisho: Ueno Shinobazu hasuike*). *Ōban*-Format. Veröffentlicht von Yamamoto, *ca.* 1845. (Siehe Tafel 21 zu einem anderen Druck aus dieser Serie.)
Zur Zeit seiner wachsenden Anerkennung malte Hiroshige eine äußerst große Anzahl berühmter Stätten in Edo auf Veranlassung verschiedener Verleger. In diesen Serien gibt es schon mehr als fünfzig Abarten, wobei die Serien jeweils von zehn bis dreißig Drucke umfassen, und so ist es wohl verständlich, daß viele der Serien gleichlautende Titel haben. Wenn man die Drucke auf Einzelbogen mit zu den Serien zählt, kommt es insgesamt zu einer riesigen Menge. Zu beachten ist, daß im Druck auf Tafel 25, einem mit hellen Farbtönen, die Verwendung von Umrissen in schwarzer Tusche vermieden wird.

27. *Busch-Klee und Frosch*, aus der Serie von Drucken für nicht faltbare Fächer, "Blumen in den vier Jahreszeiten" (*Shiki no hana zukushi: Hagi to kaeru*). Veröffentlicht von Ibasen, *ca.* 1843–47.

28. *Schneeweißer Reiher im Schilfrohr* (*Futoi ni shirasagi*). *Chū-tanzaku*-Format. Veröffentlicht von Kawashō, *ca.* 1834. Riccar Kunstmuseum Tokio.
Neben den Werken seiner letzten Jahre sind recht viele von Hiroshiges Landschaften durch Farbkomposition aus schwarzer Tusche und Indigoblau gekennzeichnet; andere Farben kommen wenig vor und sind in bildlicher Rolle begrenzt. Die Drucke mit dem Vogel und den Blumen zeigen jedoch Hiroshiges Malerei voll von hellem Kolorit. In dem Druck mit dem schneeweißen Reiher werden keine Umrisse in schwarzer Tusche gebraucht, und die weiche Flaumigkeit der Federn kommt aus der umgebenden Farbe. Außerdem steigert die farbfreie Prägearbeit bei den Federn, die in der Reproduktion nicht ersichtlich ist, die Schönheit der weißen Malerei umso mehr.

29. *Kirschblüten und kleiner Vogel* (*Sakura ni shōkin*). *Ōtanzaku*-Format. Verleger unbekannt, *ca.* 1832. Riccar Kunstmuseum Tokio.

30–33. *Frühling: Kirschblüten in Gotenyama; Sommer: Mond an der Ryōgoku-Brücke; Herbst: Ahorn am Kaianji-Tempel; Winter: Schnee am Sumida-Fluß:* die Serie "Berühmte Stätten von Edo in den vier Jahreszeiten" (*Shiki Edo meisho: Haru: Gotenyama no hana; Natsu: Ryōgoku no tsuki; Aki: Kaianji no kōfu; Fuyu: Sumidagawa no yuki*). *Chū-tanzaku*-Format. Veröffentlicht von Kawashō, *ca.* 1834.
Diese Serie gehört zu Hiroshiges frühesten im *tanzaku*-Format, von denen jeder Druck eine sorgfältige, mit Hiroshiges Lyrik reich ausgestattete Arbeit darstellt. Im *Frühling*-Druck ist die Milde eines windstillen Frühlingstages geschickt durch einen aus waagerechten

und senkrechten Linien zusammengesetzten Kompositions-Aufbau ausgedrückt, wie die durch den Mittelpunkt des Druckes laufende Horizont-Linie und die senkrechten Wegweiser und Schiffsmaste. Die milden Strahlen der Frühlingssonne werden in dem ruhigen Rosa der Kirschblüten und dem kühlen Grün des Grashanges fühlbar. Gotenyama, ein Hügel an der See westlich der Shinagawa-Wegstation auf dem Tōkaidō, war bekannt für die Schönheit seiner blühenden Kirschbäume.

Die Umgebung der Ryogokū-Brücke über Edos Sumida-Fluß war ein beliebter Treffpunkt am späten Abend für Leute, die sich von der Sommerhitze erholen wollten. Im *Sommer*-Druck ist die Brücke und der Fluß unter einem Vollmond abgebildet. Zwei oder drei überdachte Boote liegen in der Entfernung, und im Vordergrund steht ein Melonen-Händler, eine bekannte Gestalt, die an den überdachten Booten entlang zog und ihrem Geschäft nachging. Es ist früher Abend, und noch nicht viele Leute sind auf dem Fluß,—ein meisterhaft erfaßter Augenblick der Ruhe.

Der Kaianji-Tempel, der auf einem Gotenyama benachbarten Hügel stand, gab eine wundervolle Aussicht auf die See, und im Herbst zog die schöne Farbe der dortigen Ahorn-Bäume Bewohner von Edo an, die gerne spazieren gingen. Könnte es sein, daß die Figur links auf dem *Herbst*-Druck, im Stil eines *haikai*-Dichters gekleidet, tatsächlich Hiroshige selbst ist?

Ununterbrochen fallender Schnee, ein das Floß stakender Mann, eine Böschung und ungeregelt eingetriebene Pfähle.... *Winter* ist eine einfache Komposition, und doch ist die Szene von der tiefen, für Hiroshige typischen Geruhsamkeit beherrscht. Dies ist Hiroshiges eigene, in indigoblau und schwarz geschaffene Welt. Die Schneeflocken, welche die Komposition füllen,—weiße Kristalle aus Schnee gegen verschiedene Farben im Hintergrund,—üben eine lebhafte dekorative Wirkung aus.

34. *Erfolgreiche Kaufleute in Ongyoku-machi* (*Ongyoku-machi hanka no shōnin; oben*). Druck für nicht faltbaren Fächer. Veröffentlicht von Ibasen, *ca.* 1852.

35. *Der Bon-Tanz,* aus der Serie "Ein Handbuch der alten Tänze" (*Kodai odori zukushi: Bon odori;* unten). Druck für nicht faltbaren Fächer. Veröffentlicht von Ibakyū, *ca.* 1843–47.

Was ist "Ein Handbuch der Alten Tänze" und wieviele Drucke gehörten ursprünglich dazu? Gab es ein Muster, dem dieser Druck Hiroshiges zugrundelag, oder ist es sein eigenes Werk? Wir wissen es einfach nicht. Die in Hiroshiges Landschafts-Drucken auftretenden Menschen sind gewöhnlich geschickt gefaßt, in Form und Stellung,

durch einfache Pinselstriche, und es liegt um sie ein gewisser Reiz. In *Der Bon-Tanz* hat es ebenfalls Hiroshige Freude gemacht, Alt und Jung, Männer und Frauen in komischen Stellungen darzustellen. In *Erfolgreiche Kaufleute in Ongyoku-machi* stehen wir einer Karikatur gegenüber, in der sowohl die Kaufleute wie die Kunden als Schauspieler aufgemacht sind.

36. *Nachtszene in Saruwaka-chō,* aus der Serie "Berühmte Stätten in Edo: Hundert Ansichten" (*Meisho Edo hyakkei: Saruwaka-chō yoru no kei*). Ōban-Format. Veröffentlicht von Uoei, 1856–59.

Diese Serie, ein Werk aus Hiroshiges letzten Jahren, besteht aus achtundzwanzig Drucken und dazu einem von Hiroshige II; von den angeblichen Hiroshige-Drucken werden jedoch drei als Fälschungen verdächtigt. Der vorliegende Druck stellt Menschenmassen im mondhellen Saruwaka-chō dar, dem Theater-Viertel von Edo, aber völlige Ruhe herrscht über der Szene, und die Gestalten sind bewegungslos. Ob er Menschen malt, die sich an den Kirschblüten in Gotenyama erfreuen, oder das Spektakel eines Feuerwerks an der Ryōgoku-Brücke, Hiroshige tritt stets einen Schritt von dem Gerummel zurück und malt die Szene ruhig aus der Entfernung. Der hier abgebildete Druck stammt aus der ersten Auflage. Auf späteren Drucken liegt der Mond tiefer, und die unter dem Mond zu sehende Schattierung in schwarz ist fortgelassen worden, sowie die leichte Tönung mit schwarzer Tusche unter dem Dachvorsprung der Häuser. Besonders bemerkenswert sind die Schatten der Menschen auf der hellen Bodenfläche, eine stilistische Neuerung, welche der Szene eine gewisse Frische gibt.

37. *Abend-Schauer auf der großen Brücke in Atake,* aus der Serie "Berühmte Stätten in Edo: Hundert Ansichten" (*Meisho Edo hyakkei: Ōhashi Atake no yūdachi*). Ōban-Format. Veröffentlicht von Uoei, 1856–59.

Die Oberfläche des Flusses ist durch den Anprall des Regengusses weiß-blitzend gemacht, Atake-chō erscheint verschwommen durch den Regen hindurch in leichter Tönung mit schwarzer Tusche, Menschen eilen über die Brücke... Hiroshiges geschickte Darstellung von Regenszenen ist immer hervorragend, selbst in einem Werk wie diesem, das während seiner letzten Jahre geschaffen wurde. Dies ist das Meisterstück einer Serie, welche eine große Anzahl von Drucken mit dunklen Farben enthält. Die Schattierung der oben links und unten rechts zu sehenden Wasser-Oberfläche sowie des Oberteils der Brücke wurde in späteren Drucken fortgelassen. Es gibt auch eine Druck-Variante, auf welcher noch zwei Boote in leichter Tönung dazu gemalt worden sind. Die Szene wird durch die schwarzen Wolken gespannt, welche das obere Ende des Bildes bedecken.